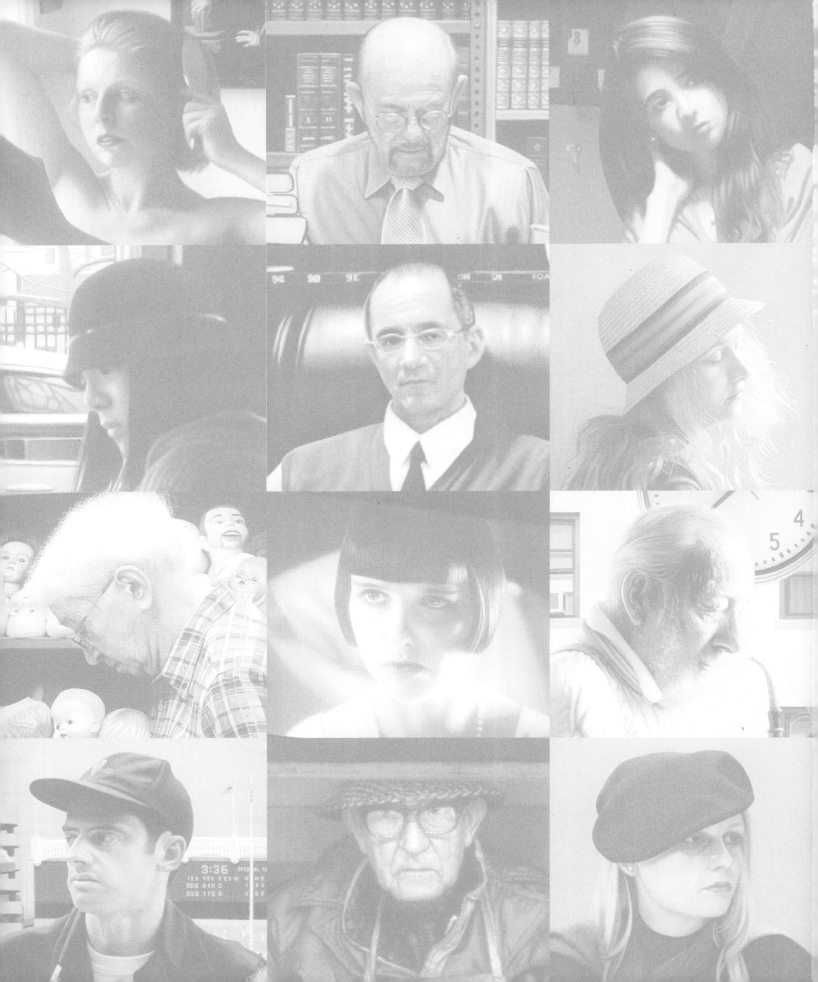

LULU IN NEW YORK
AND OTHER TALES

WORDS **ROBERT POWER** PAINTINGS **MAX FERGUSON**

Published in 2017 by
Unicorn, an imprint of
Unicorn Publishing Group LLP
101 Wardour Street
London W1F 0UG
www.unicornpublishing.org

ISBN: 978-1-910 787-52-6

10 9 8 7 6 5 4 3 2 1

Designed by Julie Meridy
Printed in China on behalf of Latitude Press

CONTENTS

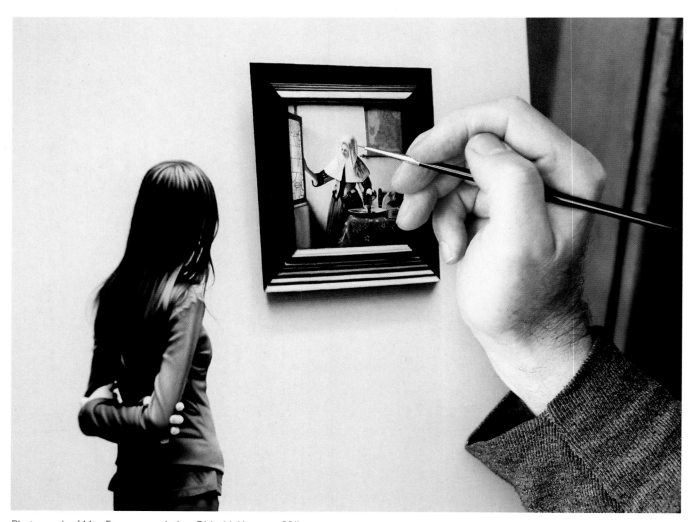

Photograph of Max Ferguson painting *Girl with Vermeer*, 2014.

MAX ON ROBERT'S WORDS

When Robert Power first approached me with the idea of writing pieces inspired by my paintings, I was tickled pink (as well as many other colors on my palette). One of the mantras in my work is that the more personal you get, the more universal you become. The idea that someone I have never met and who lives so far away [emotions without borders] could be so inspired by my work was, well, thrilling. In one sense, my work, so often populated by a solitary figure, is a soliloquy. Yet there is someone else involved: the viewer. So for me it is more like a dialogue. It's that emotional pas de deux in which I'm most interested. It is that emotional solar plexus that is my primary target. If the work speaks to the viewer on a certain primal emotional level, then I've succeeded. If Power's words had been feeble, I would still have been honored by the project. Fortunately, his words are such poetry and so evocative, with such economy of language, well, I couldn't be happier with the end result. As one friend put it who read "Girl with Vermeer", 'That's me! That's my story!' A hallmark of good art is that it answers questions about your own life, but leaves you with an air of mystery and questions about the work itself. One goal of Cole Porter's songwriting was to make it impossible to imagine the words of his songs with any other melody, and vice versa. Robert began sending his stories to me (sometimes one a day), and it became almost impossible for me to think of the paintings without associating them with his words. Nestled in between the exchanges of his work we also touched on a shared love of music (Tom Waits, Leonard Cohen, Cole Porter, et al.), and dealing with the deaths of our parents. We ultimately found common ground beyond the matter at hand, such as fatherhood in later life, and playing pool. One of the things I would like to believe art is capable of doing is bringing people together. Art as the opposite to war. Tolstoy once wrote of "War and Peace": 'It's not a novel. It's not a history.' And what are these gems of Power's? Into what little box shall we place them? Not quite short stories. Not quite poems. But the language is clearly poetic. Not in an annoying, self-conscious manner, but more like Conrad's mastery of the language and its infinite subtleties. Envisaging indeed. If Lon Chaney was "the man with a thousand faces", Power has a thousand different voices (as becomes evident in reading his other work). Miraculously, like a good actor, each of Power's voices and roles is equally self-assured and effective. One of my goals in my work is that there is something going on a little beyond the confines of the frame. Something you can't quite put into words. Something occurring beyond the confines of the page. In envisaging my paintings Robert Power has done just that.

Detail of *Strand Book Store*, 2010

ROBERT ON MAX'S PAINTINGS

As soon as my publisher suggested Max Ferguson's painting "Mr. Softee" for the cover of my short-story collection, *Meatloaf in Manhattan,* I was hooked. Something about its beauty and clarity, oddness and enigma attracted me greatly. An ice-cream truck out late at night in a gentrified area of New York. As for Mr. Softee himself? A Tom Waits, Lyle Lovett figure looking longingly out of the glass window, awaiting direction from David Lynch. The image rattled around my brain. Then some time later I wrote a very short story based on the painting and sent it to Max as a kind of thank you. He liked it. We began a correspondence, soon recognizing a kindredness of spirits. As I explored his magnificent portfolio the stories bubbled and flowed. And, without any formal agreement, or even any palpable recognition of its genesis, the project began. I'd gaze at a painting that demanded my attention. Soon enough its solitary figure, its landscape, its essence, would tell its story to me. I'd email the result to Max. Despite the time warp between Melbourne and New York, I always seemed to get an immediate response. He was always effusive and I seemed to be capturing what his paintings convey: something of the long littleness of life; the grand reflected in the small. I would look deep into each, searching the layers for the hidden narrative. Seldom did it come from precisely what was depicted on the canvas. More often from behind, or to the side.

To what had just been said or what was about to occur. There were characters looking on and in who insisted on a role. There were events offstage that meant so very much. Like a Harold Pinter play, like a poem by Sharon Olds, a song by Nick Cave, a film by Werner Herzog. Some nights I'd go to sleep with an image in my mind (Woman in Mirror 1994) and wake with her whispering what she had just seen out of the open window. Other times (My Father at Mount Sinai 2011) it was the simple empathy of shared experience, Max's paintings drawing words from a deep and special place. These were moments of striking synchronicity. We also had fun playing with place. I'd suggest a setting, such as the Gramercy Theatre (Broadway Checker 1986) to match the Audrey Hepburn theme. He'd come back with the Carnegie Hall Cinema on 57th Street: much closer to the subject of the painting. I'd say 'solicitor', he'd say 'attorney', I'd say 'road,' he'd say 'street'. And no art dealer would ever live in Queens, where I wanted to put one in an early draft of Atlantic City 1988. There was so much going on I can't remember when I became fixated on the 500 word maxim for each piece, but I think it nicely mirrors Max's perfectionism, bordering on obsession, and his exquisite attention to detail. Something's struck deep here. I can see myself story-telling Fergusons for many years to come.

LULU IN NEW YORK

oil on panel, 2014
12 × 12 inches / 30 × 30 cm

Now that the auditorium has emptied. Of the chatter and the noise. The audience filtered through exits left and right. The tide of their ceaseless words having fallen gentle as confetti in their wake: vowels and syllables, consonants and phrases carpeting the passageways, the aisles and foyer. No more footsteps, no more shuffling. No more sound. I can breathe a sigh. I can settle into the silence.

And what did they hear when they saw you? You, whose tongue has been plucked from your mouth? A song-bird in the nest, quietened. There on the silver-screen, so vulnerable, so accessible. They watched and they waited and they read the words, the scripted words, words never to be voiced. Conjuring sounds. Imagining cadence. Spoonfed love and resolution. They who know nothing of you, know nothing. But I do. I have heard you speak. Heard your laughter. Your sad confessions. Know the timbre of your singing. I keep the secret of your voice locked away.

And, now, in the blessed silence, after the event, it is our time. No sheet music to come between us; no lily-livered words, sugary words. My music. My symphony. My love song to you from the very tips of my fingers, from the very well of my being. Wordless also, reaching out as you move with such grace, with such ease. High up and out of reach where none could ever touch you, though many tried, though many thought they did. Even paid you for the charade of intimacy. You apart. Even as an innocent, the little girl forced to open a Pandora's box of sorts, you danced and you sang. And those that came to damn and blacken you, even whored a voice to speak your lines. Kept you muted and at a distance, oceans hence. They could not dampen your singularity. A uniqueness that surpassed all other goddesses of the age. Even those you bedded to sparkle at.

So I will play on, like Debussy, like Ravel, like your mother with the only love she was able to give to you. There is complicity in my serenade. There is understanding in the space that moves between us. And I will play and play, my fingers caressing the keys, my eyes fixed upon the screen as you rehearse and repeat and repeat again the movements, the expressions, the poses, the twists and turns. And I will play, for you, to you, until I am spent, until I can play no more.

Then later at night, in my single room, down by Canarsie Park, it is not your face or your hair or your skin I dream of, but your voice, the nightingale singing, soaring, and I pierce my heart with the ancient thorn of a blood red rose and I weep at the pure beauty, the exquisite pain, the echo of all that is yet unrequited, all that is yet to be fulfilled.

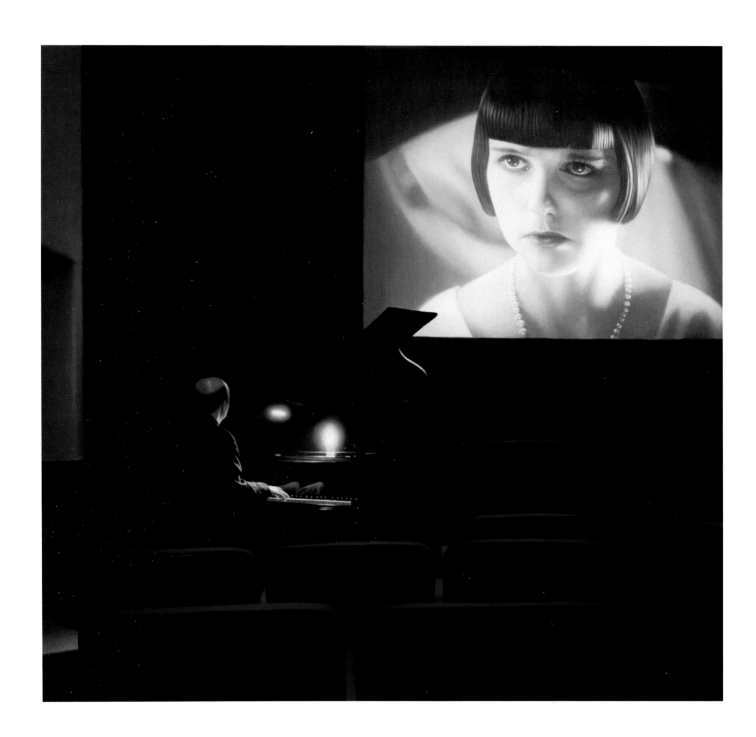

DOLL HOSPITAL

oil on panel, 2005
30 × 20 inches / 76 × 50 cm

I like Saturday. It has two "A's". The others only have one "A". But my best days are Mondays and Thursdays. That's when I come to Grandpa's shop. Sit on this stool and watch everything that happens. Then at night, lying awake, I see it all again in my brain. Every single second. I love to stop the pictures in my mind. Pause. For a special moment. Like Grandpa gluing the hair on the baby's head.

On Tuesdays and Wednesdays I go to my other grandfather. He's called Pops. He doesn't have a shop. He has a room with a big TV. We watch horse racing. On Friday I stay with my mom at our house. She does lessons with me. On the other days she's a waitress at a diner in Manhattan. She used to work on Fridays. But now she looks after me. She's trying to find me a new school, but I heard her telling Grandpa they're no schools around here for me. I used to go to school until they said I'm on the A-Spectrum. The school can't work with kids on the A-Spectrum. Adam, who was my friend, said it's the Alien Spectrum. Grandpa says it's the Amazing Spectrum and we're the only two on it.

Grandpa's teaching me things. Letting me help. I love it when the boxes come from the delivery van. Twenty right arms wrapped in tissue paper. All alike. And a box of heads. Same shape. Same eyes. Same bald heads. He lets me set up all the dolls' heads on the shelves. In order. Grandpa says it's okay to have a bit of a jumble. That life's like that. So he leaves some in a muddle and says I needn't let it worry me. Like I did the time at school when we were lining up outside the classroom. The first day I was behind Ingrid and in front of Benjamin. All the others were where they were. But next day everyone was in a different place. My head went buzzy. The teacher got angry when I screamed. Her face was so twisted. I got scared with it all and ran off. Round and round the playground.

Grandpa plays games with me. Sometimes he changes things around on the shelves. Turns one head upside down or makes the eyes look in a different direction. I always know what he's done. Just like when he switched the photos in the frame. He's helping me. He tells me how I can be in the world. How I can find my way. I tell him my secrets. Like different colors for different days. And how I see what I see. He says we are more alike than the dolls' heads. That makes me tingle. When I grow up I want to work in the Doll Hospital. Putting the heads on. Knowing how things fit together. With my grandfather who doesn't watch the horse racing. My Grandpa who's with me on the Amazing Spectrum.

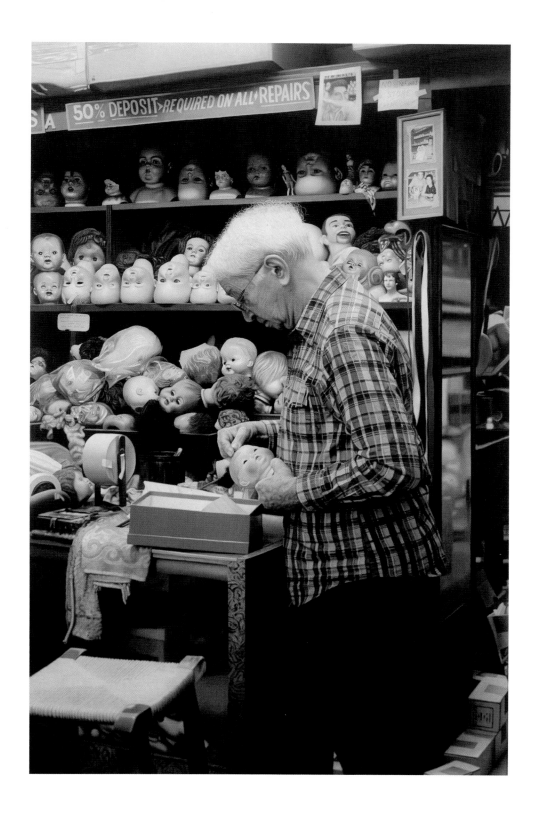

POPCORN

oil on panel, 2015
30 × 44 inches / 76 × 112 cm

"Polly the Popcorn Girl" we used to call her. Even though her name was Rachel. She was a romantic who'd worked at the Astor ever since she was a teenager. She loved films and would talk about her script writing and her dreams of making movies. I'm like Tarantino, she used to say, only he worked in a video store and I'm selling popcorn in an arthouse cinema. And, as I reminded her once, he's big into violence and you're all about love. She was always at the De Beauvoir Club on Fourth and Taylor on the last Thursday of every month. That's when they had the open mike. She'd get up among the poets and short story writers and read out snippets from her film scripts. Acting out all the voices. Though mostly it'd just be two. A man and a woman. Or woman and a woman. Even a man and a man. Intense. Gritty. Passionate. Heartfelt. She said you never know. There might be an agent in the room. Someone from Hollywood. I went to listen a few times. More Herzog than Spielberg I thought. Not surprising, given she had such a big thing for European cinema. So it was ironic that Wim Wenders' "The Goalkeeper's Fear of the Penalty" was showing that week. That last night it was a double-bill with "Wings of Desire". You know the one. Colombo with angels and no raincoat. Polly worked the late shift. It's funny thinking back.

No one had seen him before. Or knew where he'd come from. But we all noticed, without saying, that he gave us the creeps. Waiting in the corridor while we cleaned the cinema. Always with a big box of popcorn. He watched that goalkeeper movie every night. Sitting in the back row. Wrapped around in his huge coat. Afterwards we all said how spooky he was. That weird guy in the trench-coat. Like art imitating life, or whatever the cliché is. I was in the ticket booth that week so I didn't see the film. But naturally I was curious. A couple of days later I got it out on DVD and I saw what they meant. The goalkeeper losing his touch, his confidence, his direction in life. Then going to the cinema in a strange town and killing the usherette. For no reason. How crazy. And it would've been just like Polly to walk to the bus stop with him. She was so kind and trusting. And she probably felt sorry for him. What with him being alone and a stranger to town. And I reckon she would've talked to him about her latest scripts and ideas for films. They found her hat down by the river. She always wore that hat. That's all they've found so far. We all got interviewed. And we all gave descriptions of the stranger in the coat. That's all there was. Descriptions. What we'd seen. Our own bits of the story. And what we knew about Polly.

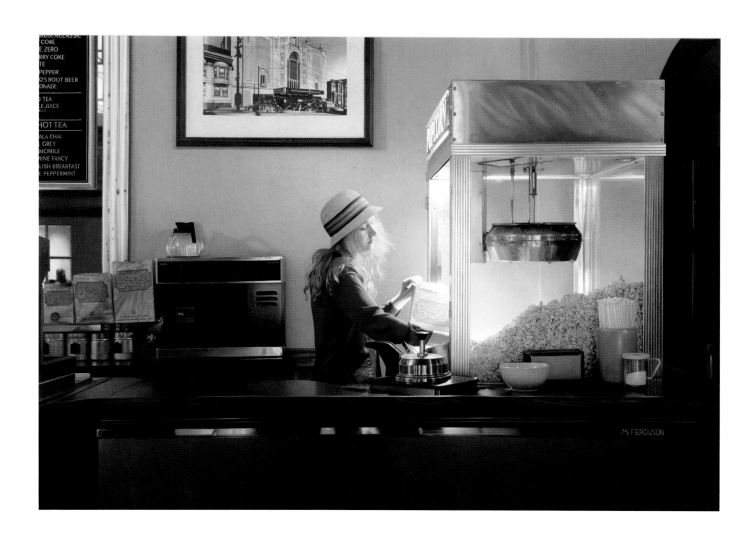

CLOSING TIME / VILLAGE VANGUARD

oil on panel, 2016
20 × 30 inches / 50 × 76 cm

Don't look away. If you turn your back on me. As you've done so many times before tonight. If you turn away and busy yourself with bottles and glasses. I'll still be in the reflection. Your reflection. Go ahead. Rearrange the Christmas tinsel. But I'll still be here. When you turn around. Waiting. Even if you close your eyes. You'll never close me out. Closing time. Opening time. It'll all be the same to me. So, turn this way. Look at me.

You cannot deny me.

I will not let it happen.

I will not go away.

Don't close me out

You say you've given me all you can. All you have to give. That you've your own life. A life away from me. You say your love lies elsewhere. That you never really came to love me. There was never the time for that to happen. For you to get to know me. You say the time has passed.

Well diddly dee, isn't that just a surprise.

Let me tell you how it's been for me. How it is for me. Let me remind you of all you've given me. Of all you have to give. To me. Birthday cards that stopped when I was ten (I've kept them all). Then the phone calls (three times, out of the blue). And a sighting (once) through the school gates when I was in fourth grade (or so I was told). I try to bring it back to mind. I squeeze my eyes closed to make my brain sift for that elusive image. And sometimes it does. Or I do. And there you'll be. Frozen in time. Silhouetted against an Arizona skyline. Waiting for me to come out of school. Waiting, so ordinarily. But even if the memory was true. My image. You never waited. You were gone before you arrived. Mom's shown me all the photos. Of she and you before. But not one of me and you. Not one to hang on to. Never in your arms. Mom says not to blame you. That you and she were kids. But she stayed? Why couldn't you? You, who even now, turn away from me.

Before closing time I got to talking with Gerry, a lovely old man who's been coming to the Vanguard forever. Gerry said that back in the day they used to have "Speak Outs" on Monday nights. One dollar to get in. One dollar drinks. There'd be all kinds of topics. People'd say all manners of things. Controversy was the theme, said my new old friend. He's an unusual man, Gerry. He said he likes the sound of the word. "Controversy". He said it sounds like it does. Well it's Monday today and maybe I'll sound like I do. Perhaps this is me speaking out. To you. Mainly in silence. No need for any more words.

Just turn around.

Look me in the eye.

Maybe we can speak out together.

Now.

Turning our backs on closing time.

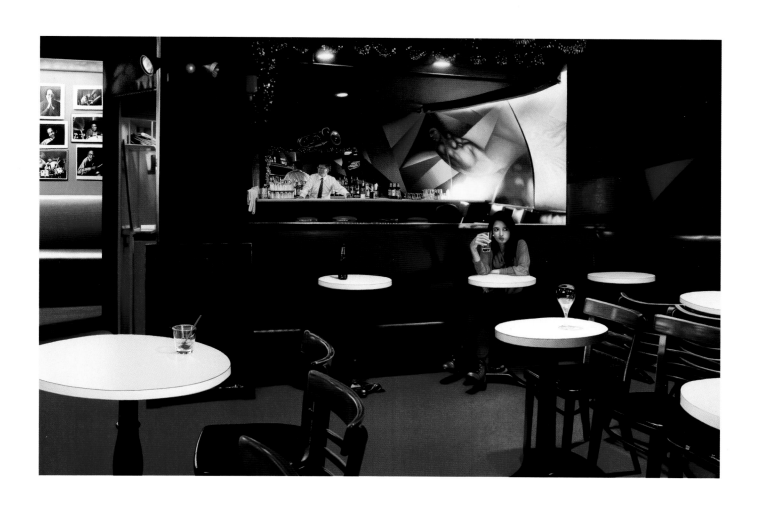

STRAND BOOK STORE

oil on panel, 2010
16 × 22 inches / 40 × 55 cm

She sits opposite him, her father. Their shared passion piled high in volumes on the table between them. A ramshackle citadel of wisdom and beauty, peopled by myriad words. This day's work, a treasure trove from a collection owned by a Dublin-born impresario, recently deceased. She observes the fine line of her father's face. He, who read to her in the cradle, when all she knew was the melody of the syllables and the marvellous smell of the paper, the comforting, hypnotic sound of pages being turned.

He looks up, his finger tracing a line in the book before him. '"You can hear the dew falling, and the hushed town breathing". How beautiful is that line?' he says, as if speaking to himself, so deep is he in the splendor of the moment. She smiles, recognizing the expression on his face. Of total absorption, of complete and purposeful commitment. Once, when a customer referred to his shop as a huge library of books, it occurred to him that the collective noun was deserving of something else, something less prosaic, less bureaucratic. 'It's a "love" of books,' he had said. And that's the descriptor he's chosen to use ever since.

They sort and judge the tomes in delicious quietude. By the cover (in spite of the old adage), but also by spine, genre, genealogy. Physicians are they; anthropologists. Tracing a legacy from Moses, from the first man with a stick drawn in the sand, clay on the wall of a cave. Each book will find its rightful place on the trolley, later to be transported to category and shelf in the bookstore that has been nurtured down the generations.

He hears the clock strike the hour. Soon it will be lunchtime. 'Tuesday,' he says '… my turn,' being ever fair, ever kind. And as the chimes ring out she holds up a slim volume, with the tender embrace befitting a new born, saying excitedly, 'WB Yeats, The Tower, second edition, 1929.'

'Ah, Yeats,' he says, rising to leave the room. '"An aged man is but a paltry thing, a tattered coat upon a stick".'

When he returns they will shuffle the colonnade of books, a city on the brink of an earthquake, and place the tray of food on the table. Olive bread, goat's cheese, sliced pear and dates.

'Our Dublin friend was clearly a Yeats man,' she says, holding up a soft covered manuscript. "A play … "On Baile's Strand".'

'So it's found its rightful home here,' says her father with a grin that's shared by his daughter.

And so the afternoon dawdles towards dusk. They spend the last hour rearranging displays in the store. Yeats will be given pride of place in the shop window. A reminder of the beauty and poise of the past.

'Two Yeats in one day!' he says, turning off the lights.

'Okay, Mr. Stick,' she says. 'Here's your tattered coat. I'll take you across the street and buy you a Guinness to celebrate our good fortune.'

WOMAN IN MIRROR

oil on panel, 1994
12 × 12 inches / 30 × 30 cm

Watching your Mercedes turn left at the end of the road. The indicator coming on at the last moment. As if the car itself had made the decision. Not turning right towards the gallery. To be sure to be on time to open up, like you told me, hastily putting on your clothes, declining a coffee. Kissing me quickly, preoccupied, as I rose to bid you goodbye. Then rushing down the stairs with your tie in your hand, letting the door slam behind you. Outside in the street you glanced up at the window. How did I look to you? You to me looked strained. Torn. Then you drove away, turning left at the intersection. Back to Brooklyn and your wife and kids. To surprise them. Telling them something like you'd gotten the red-eye back from Chicago. So that you could take the boys to school. Your wife will smile, comforted, contented, Cossetted. You might even phone your assistant and ask him to look after the gallery for the morning. Perhaps you'll take your wife for brunch. Skip over the trip you never took and talk excitedly about the summer holiday you're all planning to Mexico. You might even mention the amazing canyon near Guadalajara that I told you about last night. You'll charm her all over again. Like you did me that first time we met at the Met. Both of us looking at the same picture. You knowing so much about art, about the painter. Bronzi-no, who I didn't know. A pupil of Pontormo, you said, who I did know. I noticed your hands. That first time. And your mouth. Words. Your voice.

So, why, after all I've said, after all the times we've talked this over, why hide from me? Your intent. A left turn … a right turn. Just trust. Just believe me when I tell you this is enough. That I am contented with this piece of life we have together. With no desire to be any man's wife. Not wanting your child, nor any child at all. The domestic you I'm happy to leave to another woman. It has never been my aspiration. Soon I will pull on my old clothes. Unencumbered, unshackled by any demands. Of children. Of wives. As of every day, I'll go to my studio. There, waiting for me, patiently, exquisitely: a trunk of oak. There, a soul, a phoenix, anticipating me. To release. Unforeseen. To breathe life.

As I watched you sleeping this morning, waiting for you to wake and go. Thinking, only of … imagining the shape and form. Feeling the chisel in my hand, the lathe; the coils of wood unfurling. Soon I will walk to the end of the road. I will not hesitate. Will not be torn. I know where to turn. Passing the bakery and ironmongers. Crossing the park, the acacias newly in bloom. Then over the foot-bridge, peering between the wooden slats to the rushing waters below. Then. To my studio. My life awaiting.

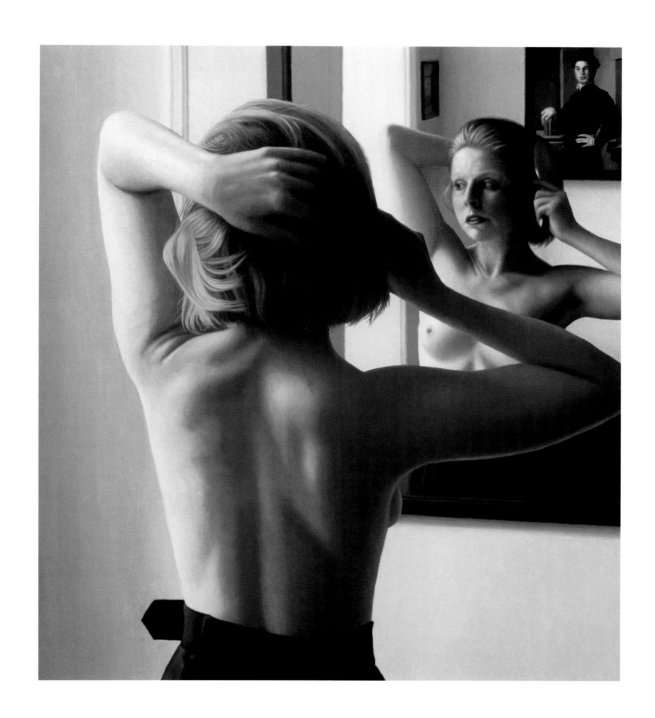

SUBTERRANEANS

graphite and chalk on paper, 1991
20 × 30 inches / 50 × 76 cm

The last train. No more stops. On the way to nowhere. Black. Shades of black. All semblance, all nuance of color sucked into the tunnel. All around entombing. Way below ground. Beneath the surface. Layer upon layer, strata upon strata.

Under ground. If there was air to be breathed it would be unbreathable. There they sit. In their allotted places. Reserved for those who have purposefully lived their lives in sadness. Lives in madness. Visionless stares. Where once there was vision. Any hope of visions now extinguished. Blind eyes forward. No crutch for support. No cross to bear, to Calvary or any other destination. All ended. The end of this or any line. The terminus, where the rats scuttle and scurry. Born in the dark, stalk in the dark. Flesh for eyes. Feeding on the discarded. A plastic doll. Hairless. Blind. Unblinking long lashed. An army of rats turning back on each other. Over and under each other. In pursuit of what might be on offer. Newspapers. Cuttings. Photos, faded, of baseball stars. Curled pages of football statistics. Columns of the NASDAQ index. Nibbled through. Rats ever searching. Serrated edges. Rats among debris. Small pools of oily water. Sheens of sickly yellow, marshy green, unfathomable blue. Water as once was. Now turned to chemical in the lightless space. Dripped from the decades of undercarriages. Flakes of rust. Metallic. Shredded from once gleaming machines, long since in decay. Rats' claws scratching from beneath. Showers of rusted flakes. Like from dead men, like from muddied snow. Rats squealing. Lusting for meat. Fresh or otherwise. The only sound, the scratching of animals. The squeals, barely heard. Feral. Determined. Paws bleeding in the effort. In the attempt. Feasting, for now, on the stains of others' blood.

Inside. With all aboard. This train at the end of the line. No return journey for you boyos. You who once were loved. Once were held to the breast. Suckled by mothers one and all. Who grew, sated on the cream and the fat, to seek out a path, a passage. Criss-crossed the continents in boxcars and trawlers. Dreamt like others. Then lost the way, if a way was ever found. Were sought out, spied out and seduced to give up their souls to the subterranean pawnbroker. Each, in time, sold for a sixpence; bounty hunted by Satan and his hordes. Gathered up in a skillet.

From up above the rumbling of tread and huge wheels. Cogs and gears; chains clanking against unyielding steel. Heavy artillery heaving through a cityscape, devoid and denuded. The thunder and rumble of terror on the move. But those way deep down in their metallic coffin hear not the sounds above ground, fear not what might this new day bring. No cowering. No cringing. Just as the scratching and claws of the rodents mean nothing to them now. Can hold no terror. Above and below, no need for Armageddon on this our earth. Our day and days of judgement already reeked upon ourselves.

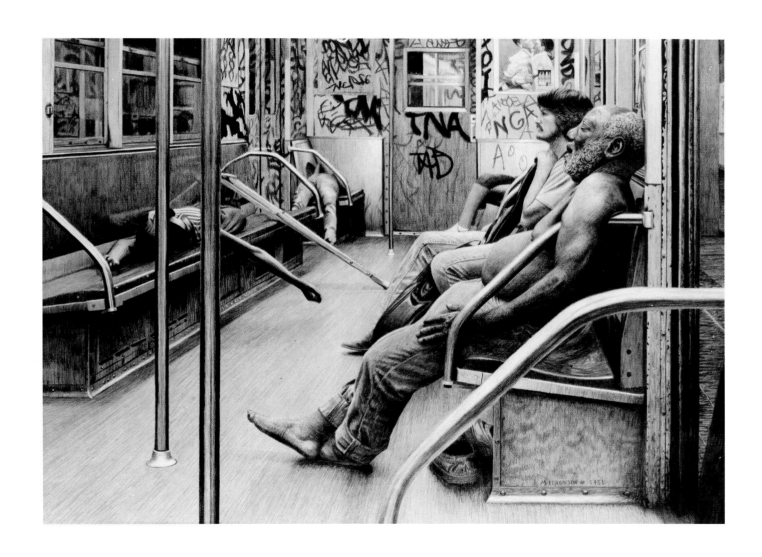

MR. SOFTEE

oil on panel, 1985
27 × 45 inches / 68 × 112 cm

When Caleb stops the truck on the corner of West 125th and Frederick Douglas Boulevard, old Mr. Dabrowski looks out of the window of his shop and turns to his wife, Anya.

'Lots of crazy people on this street these days,' he says, pointing across the road, the thimble dangling from his fingertip. 'But that's one strange looking Mr. Softee.'

'Where?' says Anya, not looking up, more interested in the line of her stitching than the comings and goings of the street outside.

It's been years since an ice-cream truck has stopped near the cross-street, what with the shootings and crack-heads and muggings. But it's where Caleb wants to be. From where he's parked, with the window slid open, he can hear the sounds from the Apollo Theatre, just up along the way on 125th Street. It's Wednesday, so it's Amateur Night.

Not that anyone comes to the truck to buy ice-creams. But Caleb stands there, long enough to listen, long enough to remember. And soon enough the music comes to an abrupt halt: a sure sign that the Sandman is tap-dancing his way across the stage, hook outstretched.

Caleb sits in the driver's seat and turns on the engine. The jingle jangles as he drives off down the boulevard.

'Blue Moon,' says Mr. Dabrowski, '… the tune.'

'What?' says Anya, looking up from her sewing, pricking her finger, sucking the blood. 'Now look what you made me do,' she says, a single droplet of ruby red staining the edge of the dress.

Next Wednesday and there's the Mr. Softee truck. And there he is. Looks the same. Stands the same.

'I think he's staring at us.' says Anya, glancing up at the man in the white shirt, illuminated by the fluorescent light from within the truck. 'How things have changed,' she adds with a sigh.

'No,' says her husband, 'he's just looking out. Waiting for business.'

'Just like us,' she says.

'Yes, just like us,' says Mr. Dabrowski.

Caleb opens the glass door at the front of the truck to let the night air and the sounds drift in. It's windy and the music and singing from the Apollo swirl around with the ebbs and flow of the breeze.

Mr. Softee strains to hear.

All the while, offstage, in the wings, looms the Sandman: judge, jury and chief executioner.

"Whoever told you that you had a voice?"

It's a week later, Wednesday night, and there's no sign of the Mr. Softee truck. Mr. and Mrs. Dabrowski are working late, busily finishing off the ball gown for Mrs. Hindhurst and adjusting the tuxedo for her husband. From time to time one or the other looks up, not quite knowingly, but noticing what's absent from the street.

'Blue moon,' sings Mr. Dabrowski in little more than a whisper, 'you saw me standing alone …'

'… without a dream in my heart …' joins in his wife.

'… without a love of my own …' they both sing together, both smiling as they carry on with their tasks.

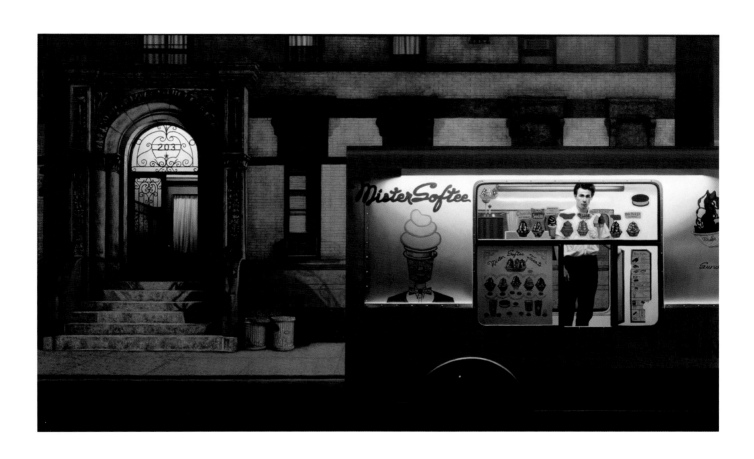

COUPLE IN HALLWAY

oil on panel, 2009
12 × 9 inches / 30 × 22 cm

'John, give me the key?'

'You don't mean that.'

'I do. This time I do. Really.'

'Honey, it won't happen again. I promise.'

The look in her eyes. Defeated. Saddened. Angry. Sadness in her voice.

'I waited up all night. All through the night … just give me the key.'

'I'm so sorry. I really am. I promise. Just give me one more chance.'

Last fall, when she handed him the spare key to her apartment she trusted him so completely; they had promised each other so much. This was going to be for real. So what that he had a reputation in the Village and beyond. She'd heard that. But she refused to listen to her friends. Even Julie from the diner who'd had firsthand experience. No, this was him and her. Her and him. *Amor Vincit Omnia.*

A whole year together. An idyllic time. A time of beauty. Of trust and complicity. Each keeping to the promise of never discussing old lovers. Never describing old love. It was John's idea, from the very beginning. He said retro-fantasy always messed with his head. He could be as jealous of old lovers, ones he'd never met, as he could be of the here and now. Nothing was to spoil the intensity of their love. They would be the latter day Adam and Eve. Keeping it pure and new and innocent. Starting all over again in their very own Garden of Eden. And so they did. They only had eyes for each other. Soul mates. Body mates. Yet they kept their own lives. Their own interests. Their own friends. Their own apartments. On their anniversary, twelve months to the day and hour from when they first met, John got down on his knees and said he worshipped her, adored her and could imagine them growing old together. They were in Central Park. Leaves falling from the trees. She leaned back against a mighty oak, feeling the ribbed contours of its bark in the small of her back. John bent forward and kissed her. She had never felt so vulnerable, so complete, so enamoured.

From upstairs comes the sound of a baby crying. The sounds she had hoped for herself. Dreamed of even: in her sleep; in his arms. The culmination of their love and passion. Life's longing for itself, indeed. She looks up at him. The hat she'd bought him in Chicago. Playing chess against the hustlers down by Lakeshore Drive. He'd beaten the grandmaster from Kingston Jamaica, with three seconds left on his clock; he'd taken the five bucks, then tipped his hat to the wind, and smiled. A moment she remembers now, she feels so exquisitely now: the thought then of wanting his child. Of wanting him, forever.

So close. The wall against her back. The wall against his. The space between them. Now so huge. And the smell. Of Wild Turkey. Of women.

She wants to speak before she cries. Before she crumbles.

'Just hand me back the key.'

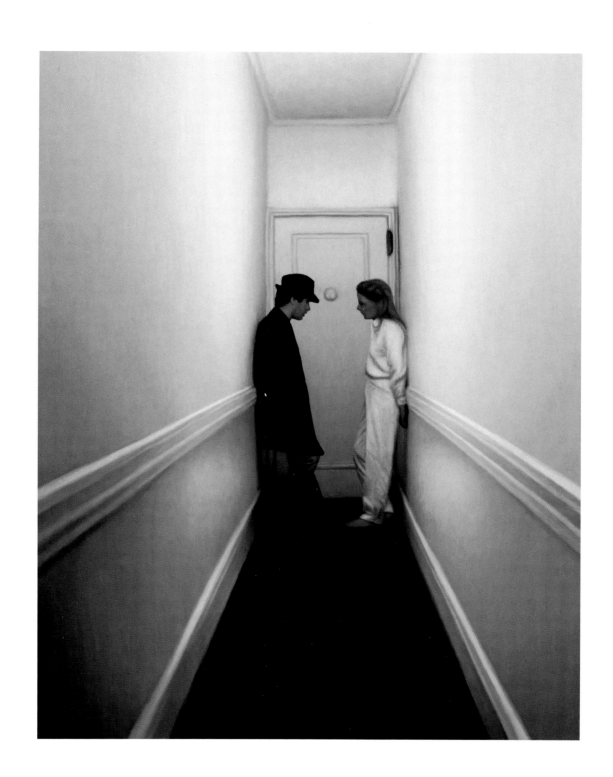

DIGNITY

oil on board, 1999
11 × 14 inches / 28 × 36 cm

Rhett's the sort of guy who weighs up all the options. Responds rather than reacts. Ice-cool in adversity. Measured in triumph. These are the qualities that have landed him the dream job on Wall Street. Rhett's a consummate operator. Fresh in from Chicago, his plan is to sit back awhile. Assess what goes on around him. Bide his time among the slickest of city slickers. Last night, after Rhett's first day, Bud (Vice-President, Futures) slaps him on the back. "You're with the big boys now. Watch, learn and get filthy rich".

Next morning, coffee-to-go in hand, he settles into the shoeshine chair thinking he'll close his eyes for a few minutes. Focus on the day ahead. So when the man asks him if he wants a "one-shoe" or a "two-shoe" story, Rhett pauses a second, does the calculations, then tells old Joe he's in a hurry and gambles on a "one-shoe story".

'Okay,' says Joe, dabbing the tar-black polish onto Rhett's favorite brogues, 'I need three words for a "one-shoe story".'

Rhett pauses. Ambiguity disturbs him.

'What do you mean? Three words?' as if a robbery is in the offing.

'Easy,' says Joe, head down, focusing on his work. 'The first three words that come into your head.'

So Rhett looks up beyond the canyons of steel and glass. The razor-sharp lines of the buildings guide his gaze to the bright blue New York sky. He's not good at spontaneity. Not good at making a call without knowing all the variables. Yet there's something beguiling in the familiar smell of the polish. The sound of the bristles of the brush on soft leather. For once there's no computing. No algorithm.

'… space,' he says. '… grass,' he adds. '… porch,' he all but whispers.

'Good. You got the idea,' says Joe, making small circular movements with the brush, working the polish into the shoe's upper.

Later that same day, long after Joe has taken the bus back home to Queens, Rhett eases into his deeply upholstered chair, stretches out his legs and rests his feet on the solid mahogany desk. His shoes are as shiny and luscious as when they were new. The market's closed; the clamour and frenzy silenced. The sky is fading to a salmony pink. Softening the edges. The New York day pushes towards night. Looking out of the floor-to-ceiling window images and sensations from Joe's one-shoe story come back to him. As they have done all throughout the day. A persistent anthem, a hymn, almost a prayer. Intruding, insisting. Stroking, nudging against the urgency, the tenacity of the day's work. Exposing and then denying him his sense of grandiosity. Now in the quietude, he brings back to mind the sound of the old man's voice. The beauty of his story's message. The surprise that a shoeshine man, three random words and a tale of simplicity, strength and reconciliation can captivate him so. Tomorrow he will wear his loafers and then, humbly, courteously, ask Joe for a two-shoe story.

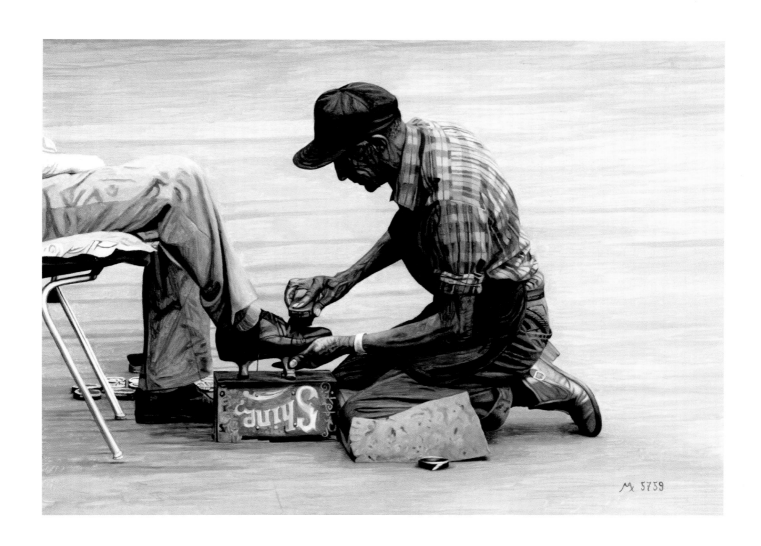

BROADWAY CHECKER

gouache on paper, 1986
26 × 26 inches / 66 × 66 cm

'I've found him.'

'…'

'Jacqui?'

'… I hear you, Si.'

'Don't hang up on me. Please, not now. I'm sorry about what I said. We'll talk about it later.'

'…'

'He's sitting on the bench. He's reading the paper.'

'He's not reading the paper.'

'Well … he's holding the paper. Looking at it.'

'Yes … looking at it, Si.'

'He's looking at it.'

'So he's at the park … like I said.'

'Yep … you were right, Jac.'

'Waiting on the bench?'

'Yep … just sitting there … like you said … with the paper … waiting.'

Their father was not always lonely and lost. He'd not always worn a battered cap and food-stained jacket. But, sure enough, this was his bench. His and his one and only sweetheart's.

'Jac … does he know where he is?' — 'He always ends up on that bench. Mostly on Fridays. Because of the cinema.' — 'So he knows it's Friday?' — 'Don't ask me how. But he always knows it's Friday.' — 'So, Jac, what do I do now?' — 'What d'you think?'

The bench on upper Broadway soon became the place they'd meet after work. He was always first there. He loved the anticipation. Looking out for her in the crowds spilling onto the street from the stores at closing time. He'd gasp at her beauty as she came into view. In her Audrey Hepburn turtleneck, cropped trousers and ballet flats. He only had eyes for her. He only ever had eyes for her, even once they got married, even after the kids came along. On Friday nights they'd go to the Carnegie Hall Cinema on 57th Street. They'd hold hands and he might steal a kiss as the lights went down.

'He looks so desolate, Jac … just sitting there … Jac, you hearing?' — 'Don't you think I know how he looks? I'm the one left dealing with this. The walk-abouts. The shitting in the yard. The crazy stuff he says to the kids.' — 'Yes … I know … I do … since mum passed … how hard it is …' — 'You know nothing, Simon. You come here twice a year. With your senti-mentality. Your frothy memories. Just try washing the pissy pants. Have him wake you up at two in the morn-ing asking if I want to see "Charade" at the Carnegie.'

'I'm sorry, Jac.'

'Sorry makes no difference. You take him. He's your father too, or had you forgotten? You take him back to Skokie … to your perfect Barbie-doll wife. She can clean the shit off the kitchen floor. '

'Jacqui …'

'…'

He looks along the street. Soon he will spot her in the crowd. His heart will leap as it always does. She will join him on their bench and they'll act out that scene they adore from "Roman Holiday". He'll be Jo Bradley and she'll be Princess Anne. She'll fall asleep on the bench, pretending the sedative has made her swoon. He'll take her hand and kiss her on the cheek. She will open her eyes, her beautiful eyes. And she will smile. His one and only. His own true love.

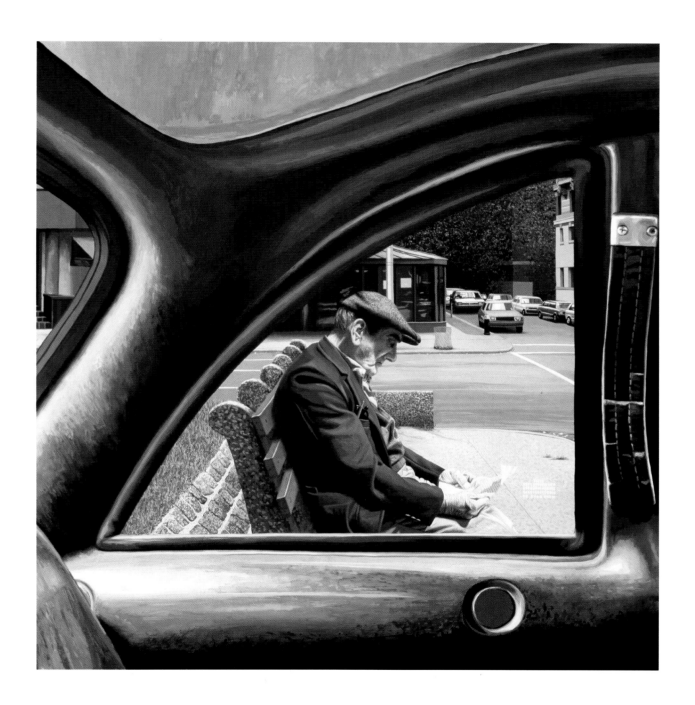

CHESS PLAYERS

oil on panel, 1991
30 × 19 inches / 75 × 48 cm

'Everyone knows that.' — 'Not everyone.'

'Well most people.' — 'Not me. Well not until I heard it on the radio on Sunday night.'

'Well I knew.' — 'More moves than atoms in our solar system?'

'That's what they say.' — 'I can't believe it.'

'It's been proved.' — 'Who by?'

'Mathematicians. They've done all the calculations and proven there are more moves on a chess board than atoms in the solar system.' — 'How can they prove it?'

'Beats me. But I heard it. Like you did. On the radio. On Sunday night.'

'Okay. I can see that they can work out the moves on the board. Calculus. Geometry. Something like that. But think of it this way. If we make something … hey, like when a new baby is born … then surely there are more atoms than there were before.'

'Maybe. I think I read that there are always the same number of atoms but we keep reusing them. Like the water we drink was the same water drunk by the pharaohs. Anyway, I think the point is that there any many, many more moves than atoms. Like to a big factor. Many times more.'

'It just doesn't seem possible.'

'Lots of things don't seem possible. That's what they said about flying to the moon.'

'That's not the same thing.'

'I'm not saying it's the same thing. Just that people think things aren't possible when they don't understand them.' — 'But getting to the moon is about progress.'

'And?' — 'Well progress. Not calculations.'

'Sixty four squares. Sixteen pieces on each side. Black and white. And so many moves. So many possibilities.'

'That's what they say.'

'How many games do you think we've played?' — 'Who?'

'Who do you think? Me and you, I mean.' — 'Me and you?'

'Just me and you.' — 'Plenty.'

'Well. Let's say forty years. Every Thursday. That's forty times fifty, give or take a week.'

'Holidays and sickness. Weddings Bar, Mitzvahs.'

'Deaths.'

'Yes deaths. Funerals. Well let's say forty times fifty and three games each night.'

'That's … twenty thousand.' — 'It's two thousand.'

'What?'

'Forty times fifty is two thousand … not twenty thousand.'

'… oh yes, so six thousand. Roughly six thousand games.' — 'That's a lot of games.'

'And about fifty moves a game. So three hundred thousand moves.'

'That sounds right.' — 'Not many atoms.'

'About as many as in one chess piece maybe.'

'Maybe.' — 'Plenty more moves to go, eh.'

'Yes. And it's yours.' — 'What?'

'Your move.' — 'I know, I know. I've been thinking.'

'I know you have.' — 'You said you didn't want to play with the clock.'

'I know I did. But it's obvious.' — 'What is?'

'The move. There's only one move.' — 'Don't hurry me. It's my move.'

'Yes, but there's only one move. The knight.' — '… which knight.'

'Which knight? Are you serious?'—'Ah, yes. Only one move.'

'That's the one.' — 'I think I played that same move last game.'

'Yes, you did. D4 to G6.' — 'So it won't count.'

'Not in the big scheme of things.' — 'But in this game.'

'Yes.' — 'Yes.'

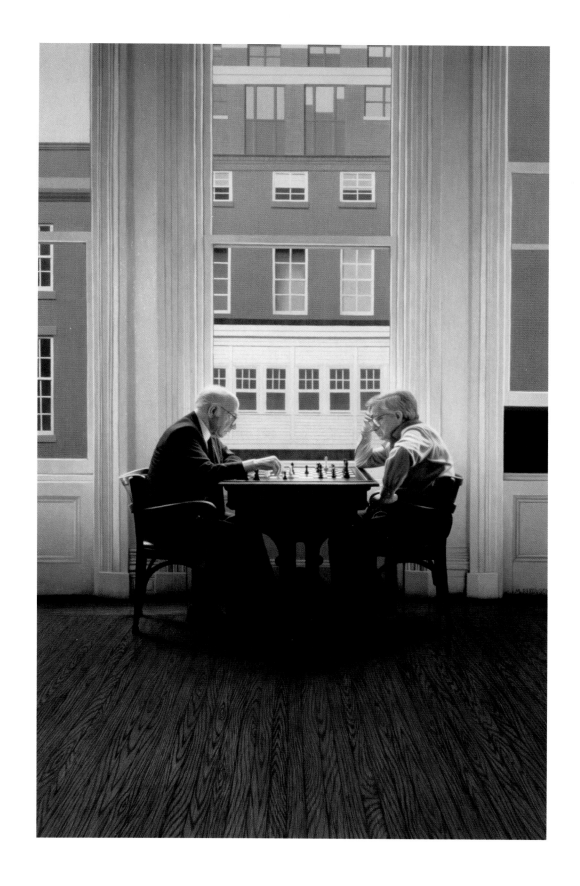

BOBBY SHORT

oil on panel, 1996
19 × 30 inches / 48 × 76 cm

Rebecca was the new coat check girl at the Café Carlyle. Not for life (she had other ideas), but the place was buzzing and she loved the music.

Paul was the sharp, slick-haired adman, constantly conjuring the elusive million dollar jingle. Always trying them out. Maybe that's why he liked Cole Porter so. And Bobby Short at the piano on Thursday nights.

Paul fell for Rebecca at first sight. This drop-dead gorgeous brunette handing him a coat tag. He felt the magic in her fingertips, even if she appeared not to.

From then on he'd wear a different coat to the Carlyle, just to impress Rebecca. He'd try joking with her, but she was always too busy. He'd drink his Jamaican rum then manufacture excuses to go back to the cloakroom. His silver art deco cigarette case. A freshly laundered silk handkerchief. His first glimmer of hope came when she looked him in the eye and said:

'What've you left behind this time?'

'My heart,' he replied. Seizing the moment. Without thinking. His "heart" from the heart.

She smiled. A smile he would come to love until the day she died.

He handed her the metal tag and sang:

'If you could find the coat ... that would be kind, he wrote.'

'Did you make that up?' she asked.

'Afraid so.'

'And do you?'

'What?'

'Write.'

'Sort of. But not the kind I want to write ... but I will for you.'

Rebecca looked at Paul, Not for the first time. But perhaps for the first first-time. Maybe, she thought, we could make each other happy. And, I'd bring a nice Jewish boy home to please my mother!

Then she thought of her plans to head to Europe.

But love derails plans as love does.

So, late into the evening of the fourth Thursday, when she was on her break, he asked her for a dance. She said 'I'm not allowed to'. He sang: 'Fake a chance ... be free, take a dance with me.' Rebecca looked up, quizzically. Paul held out his hand.

And so, the greatest and only romance of their lives announced itself to the dance floor. Paul and Cupid had timed the moment to perfection. 'You've got that thing ...' sang Bobby Short. '... the thing that makes birds forget to sing.'

And so it began.

A slow smouldering love.

———

Palm Springs, Florida.

Bobby Short lived and sang to be eighty. But he's been dead some four years now.

It's later in the day as Paul and Rebecca drink in the last deliciously warm fragments of the sun. Paul has been whistling a song that sent them both back to fond and cherished memories of the Café Carlyle. As they rise from the bench where they've been sitting they reach for each other's hand. Out of habit. Out of complicity. Out of tenderness. The feeling, as skin touches skin, is of music and youth. But most of all, it is the sensation of the enduring power of a true and heartfelt love.

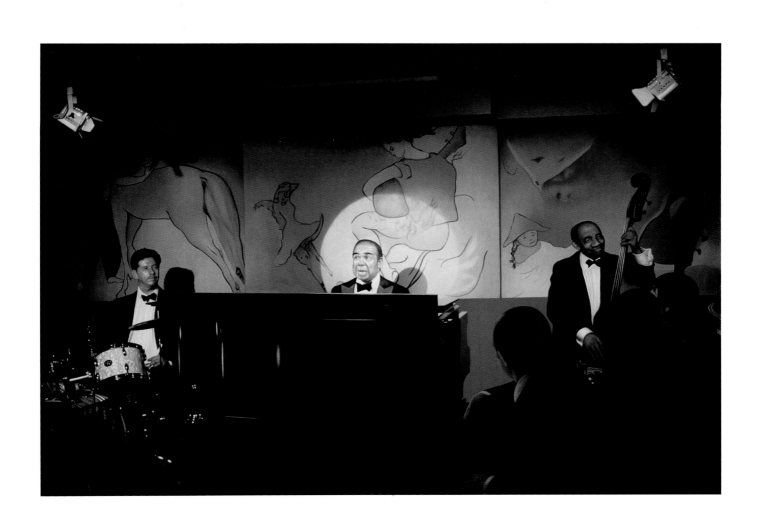

RESERVOIR IN SPRING

oil on panel, 1997
7 × 48 inches / 18 × 121 cm

The gust of wind I'd waited for. The soft petal gently held between my thumb and forefinger: a fledgling; a blood-stain. Then I let it go, blowing gently, the warmth and feel of my own breath on my skin. The petal flutters, lifts and twirls, then takes off into the slipstream. It twists and turns, through the gap in the wire fence, swooping once, low and in danger of being marooned on the barren bank. Then the wind revitalizes and soars once more, sweeping up the petal, the morning sunlight catching its sheen: a salmon on the rise, leaping then coming to rest on the water's edge. Singular, away from its home. Bobbing and drifting as the breeze ripples across the clear reservoir pool. A tiny splash of pink. A cipher. A kiss. Adrift on its own special journey, dipping and rising on the inland tide.

Cherry blossom trees circle the banks of this man-made lake. As vibrant and as vital as the old tree I remember from the orchard at the back of our house. Planted by my grandfather when his arms were strong, his hair a chestnut brown. The solitary cherry blossom tree that grew proud and firm amongst the apples and lemons. One that faithfully emblazoned the sky each spring. Me, the small girl lying on my back, looking up through a vermillion snowfield suspended above. Squinting. Filtering the mid-morning sun. Pink blossom nestled in my red hair. Holding out my hand. Palm upturned. Waiting for one special petal to fall. Watching the fragile gems free themselves from branch and twig. Parachuting earthward. Delicate. Ephemeral. Maybe a minute. Maybe an hour. Then, as if pre-ordained, a petal would settle on my hand. Softer to the touch than the ear of our puppy dog.

Now, watching its progress, the water's surface gently cradling the petal in its wake. All the while around me others walk dogs, push strollers, luxuriating in the warmth. Some stretch and jog around the perimeter of the reservoir. On the other side of the huge expanse a kite rises in the air. A triangular dot, surging, relishing the upward current. Way above our gentle breeze. Hurtling upwards, just as the petals drift slowly downwards. The red. The pink reds. Festooning the gravelled pathways. Joining, mirroring their own reflections in the puddles.

And me revisiting the little girl, in the orchard at the back of her house, lying amongst the windfalls. The fresh springtime grass warm and damp through her thin blue-checkered dress. The dress her mother bought her for her sixth birthday. The blue-checkered dress that she felt so happy in the wearing. That she would cherish until it fell from her in tatters. That girl, innocent and pure in the moment, watching the petal fall, from a speck to a penny, coming to rest on the soft skin of her hand. Dreamy in the ripening.

The trees. The wind. The water. The dewy spring grass. Cherry blossom petals in her thick red hair.

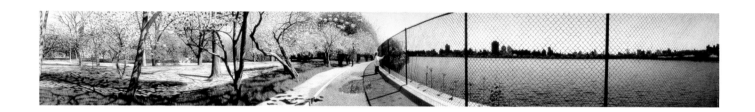

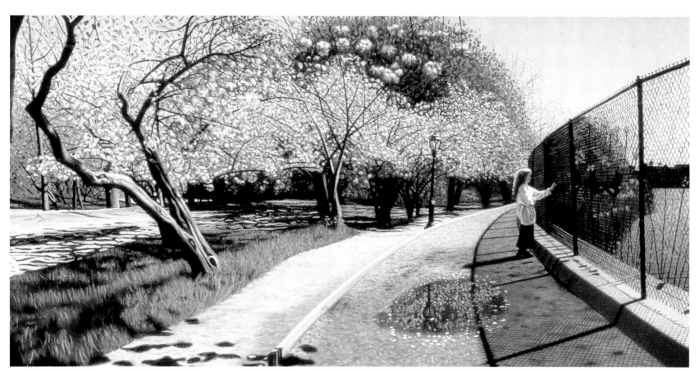

Reservoir in Spring, 1997 (detail)

BLEECKER STREET

oil on panel, 1984
30 × 40 inches / 76 × 100 cm

So you're sorry. Sorry that you don't love me anymore. Sorry that it's not meant to work for us.

Great timing. Your message, I mean. Five minutes before I was due on stage. You must've known I'd see it before I went out there. Standing in the wings. Checking the good luck texts. Even got one from your mother ("You've really hit the big time. I saw Joan Rivers and Lenny Bruce at The Bitter End when you and Ronny were but twinkles in an eye! Break a leg, sweetie. Love from the one who brought loverboy into your life. xx"). And there was your greeting, nestled in amongst them all. A black hole in a sparkling galaxy. I can only think your timing was deliberate. Like method acting. Like the way you've always said my delivery needed toning down. Less upbeat. More deadpan. Go in hard, get out early. Wasn't that what they taught us at acting school? If you wanna be a stand-up. In hard, out early. Like you and me, eh? Full on from the beginning. To the end? But I wasn't ever planning to get out, early or late. It seems like that'll be you. Your plan. In this comedy imitating tragedy.

But it worked. You slowed me right down. Like I was in a trance.

If you want to know, the routine went over really well. I ran with the hipster café number. Started off with the gag about menus dribbled into the sawdust on the floor. Then about the new super seed that no one could pronounce except for the waiter. From Peru.

And how you know it's good for you by the length of time it sticks between your teeth. Perfect for the Village crowd. But your "sorry … I realize I don't love you" kept rolling around the back of my mind. So. Less manic. So. More … measured … subdued.

Thinking about it, maybe I should arrange for a catastrophic surprise just before every gig. Like shock therapy without the electrodes. To keep me detached. Mono-toned. To get my timing right. Yes. And then I could build it into my act. The way so many comics do who've just had a baby … or turned lesbian. Pooh and hairy legs. Leaking breast-milk and furry cups. That's it. I'll run a new routine about emotional pain as the alternative to lithium for manic-depressive stand-ups. And maybe something else (not about the baby we talked of) … but about the comic jilted on her big night. Like the small-town gladiator at the Colosseum in Rome. This funny girl from Avonmore, Pennsylvania. At The Bitter End, 147 Bleecker Street, NYC.

You say by the time I get home you'll be gone. Better that way, you said. Well the M train's late, so there's no hurry.

They liked me. At The Bitter End. They want me to come back.

I want you to come back.

To me … please.

Not in hard. Not out early.

Not this too too bitter end.

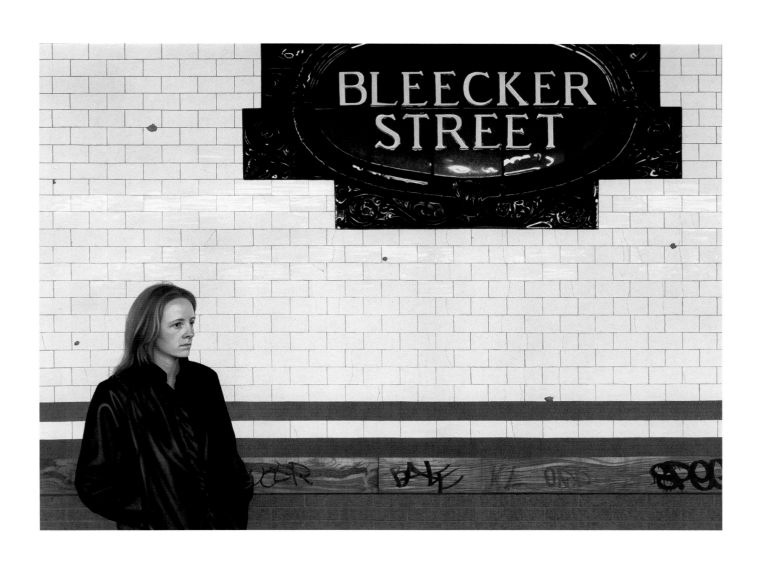

SPRING STREET

oil on panel. 1984
16 × 24 inches / 42 × 61 cm

Standing on a deserted platform. Much later at night than I'd expected. Something about the puddles, the sound of dripping water. The darkness of the tunnel. And the sensation of waiting. It brings back a memory. Almost a haunting. From the time I used to take the train from Morristown, New Jersey, to Penn Station. My John Cheever days. The suburban idyll. Closer to nature. Last I heard she's still there, my first wife. It always suited her better. Teaching in a small town. National park on our doorstep. But then she never did the commuting thing. The long rattling journey back and forth, forth and back. And that one night. The one I'm thinking of now, as I wait. Late at night it was. Drinking had happened. And other stuff best left. The last train home had emptied of all but me. Rattled from my stupor as the train shunted to a halt. Above ground, for what it was worth. Ahead of us a signal flagging red, illuminating the outline of houses skirting the train track. I look up as a window comes lit. Clearing the mist on the glass with the back of my hand I see a woman. Her expression. In distress. Pleading eyes. The shadow of a shout and the raised arm of a fist. Now, waiting at Spring Street station, reconstructing, reconstituting the memory. Reimagining, reseeding the internal world of the room. How much did I really see that night? Any night? The

story behind the face. The sobs following the blows, aware mainly of the sadness of signals being red and the lack of movement. A door slammed. Did I hear it? Like exploring a new lover, the woman runs her fingertips tentatively, tenderly, across the craters and mounds and bruises of her face. Behind, how do I know? he (her husband? is he still?) crawls across the floor, pushing aside, like a swimmer, the shards of a shattered plate, the bits of food. He hauls himself up to the window. Into my view. The cooling glass and the rivulets of rain outside comforting the stings from his face. He notices a smudge of blood by his eye, vying with the raindrops on the window he caresses. A pair now, in togetherness. Looking out. Below they spot a man alone. On a train going nowhere. Looking up, for hope, for succor. The rain beating through the night. Along the track, a signal, still red, raised like a broken arm. Like the old days.

Maybe I'll give up on the train that seems not to come to Spring Street station. Get back above ground. Take a walk in the dark along Third Avenue and see where it takes me. See what the trees are doing in the early hours of Soho Square. And is she still there? She at the window? She that I saw one night when it all came to a stand-still, with the crunching and hissing of brakes. In an unhappiness of trains.

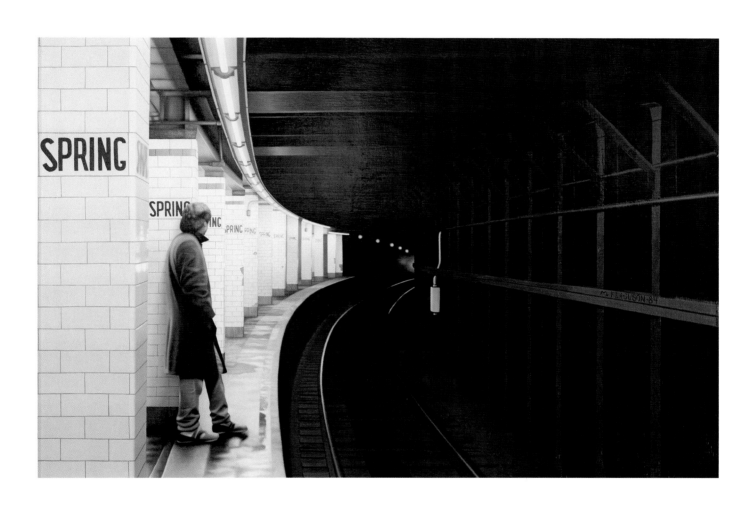

BAGEL BAKERY

oil on panel, 1996
29 × 29 inches / 73 × 73 cm

'So who hires a poet?'

'You're right Dad. No one hires a poet.'

'So there are no jobs?'

'Yes, that's right Dad. There're no jobs for poets.'

'So why do you want to be one?'

'I don't just want to be … I am one.'

'What do you mean you are one?'

'I'm a poet. I write poetry.'

'That no one pays for? No one will ever pay for?' [… I only want the best for you. You don't know how cruel this world can be. How dreams are ripped to shreds. I want you to be happy. And, yes, successful. Sure I want to boast. So your mother and I can be proud of you …]

'Who'll ever marry a poet?'

'What if I don't want to get married?'

'And break your mother's heart?'

'It won't break her heart, Dad. Maybe I will get married. Maybe I will.'

'So maybe you'll get married … maybe you won't get married … you might be a lawyer … mightn't be a lawyer … your arts degree will get you a job … maybe it won't get you a job. So you waste your education?'

'No, Dad. My degree helped me find who I wanted to be.'

'You said … you promised … when you changed from law, when you begged us to understand, even though you'd always said you wanted to be a lawyer. A real job. Something we had worked for all our lives for … for you. Getting up. Baking. Day after day. Year after year. I told myself. It'll all be worth it. Because my son'll get a law degree. A career. And our work will be done. And when you changed. When you said the law wasn't for you, you promised you'd still have a real job. Out of the shop. A career. A teacher. Even, advertising, I thought. But a poet?'

'Yes, Dad … you thought. It was you thinking for me. Telling me what I would be. Who I should be. Not the shop, you said. Like you. Like your father. Like his father. So you can tell all your friends, all the relatives, what you'd done. What a son you'd produced. But I never wanted to be a lawyer ever. It was to please you. You.'

'Don't you lecture me. You know the story … I'm proud of our family … our business … our place in the community. When my father took me out of school to work here I vowed this would not be the way for my son. That was my aim … my goal.'

'Yes, Dad. Your aim. Your goal.' {… when I could all but walk. Watching you, my father, my hero. At work. The smells, the taste. The warmth of the oven. A master of a craft. So many smiling happy faces. Men, women, children. Then … now … for you to be proud of me. For you to love me …}

'And your goal? To be a no-hoper? With the beatniks, the drop-outs? Is that what you want?'

'No Dad. It's not that. Not that at all.'

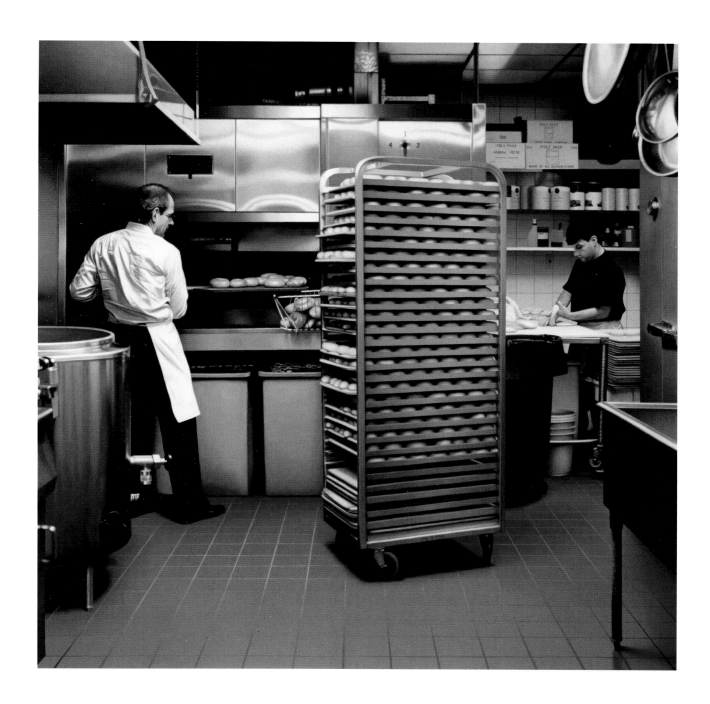

JUKE BOX

oil on panel, 2016
18 × 12 inches / 46 × 30 cm

Not the Patsy Cline. Too clichéd. Even as crazy as it's been. Ever since the summer.

It's creeping past midnight. The bus is waiting outside. The driver just called out we've five minutes to departure. Then I'd better not risk Bohemian Rhapsody. Not the KD Lang either. Too close to the bone, as they say.

So you won't be coming after all. No Thelma and Louise. No Kathy on a Greyhound Bus looking for America.

It was good of you to let me know. To call me up. Not just to leave a text with an unsmiley face. At least I got to hear your voice. To sense how sad you are. You said you were sorry. That you had your bags packed and ready. You'd even left the note on the mantelpiece for your husband. So like you. So old school. You said you've already shredded that message. Mixed it in the recycling bin with the empty dogfood tins and milk bottles. Like our love, I replied, with a timid attempt at irony. You even said "in the final analysis" (words you often use in your English classes), when you told me you couldn't bear to leave the kids behind. Remember that magical weekend at the beach when you said the time was right? That the twins'd soon be off to college. That our moment had come. Maybe there's more to leaving behind than leaving behind.

If this was a movie then I'd be playing "our song".

To heighten the scene. To match the mood. But I'm not sure we have a song. So it's no go to country, there's no need for blues, more like dancing in the street in my blue suede shoes. You see. It's okay. You taught me poetry. You showed me how stories can unfold. Strong powerful women. Carving out their own lives. Their own loves. I'd sat at the back of the class. My hair covering my face. But I hung on to your every word. Of Sylvia Plath. Of Sharon Olds. Of writers I'd never heard of. Adrienne Rich. Eileen Myles. June Jordan. I hid behind the veil of my own curls. Catching glimpses of your beauty. Your body. And through the flames I felt desire ignite. I swooned at the sound of your voice. When you read from Orlando and told us of the magnificence of the Bloomsbury set. The wolves and bells aringing. Lust and loving in long lush English meadows. Of rolling hills and misty heathlands.

You mightn't be beside me on the bus. But it was you who set me on this journey. Opened up the frontiers of a life unimagined. California dreaming. Like I've dreamt every night since you told me to dream a little dream of you.

So don't be sad, my love. Hey, maybe I'll find us a song. To be our song. And I'll sing it. On the road. All the way through the night to San Francisco. With flowers in my hair.

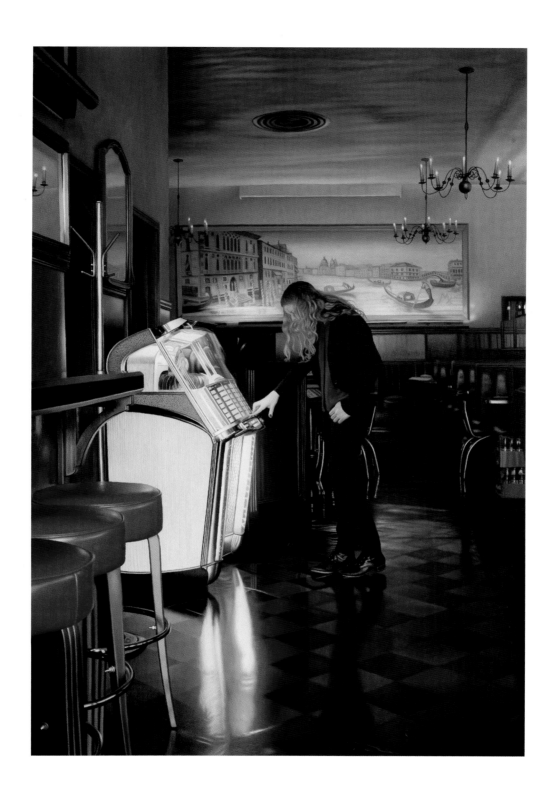

MAN ENTERING SUBWAY STATION

oil on panel, 1983
16 × 18 inches / 40 × 46 cm

If you turn now, if you try to run, you'll have missed your chance. You'll see two men, let's call them my colleagues, at the top of the stairs. And they're willing and able, though that's not their real names. Waiting, hungry, eager for action. It's in their natures. So there's really nowhere for you to go.

You seem a little surprised to see me. But maybe a bit relieved as well. The waiting's over, yes? No more having to look into the shadows. Checking under your car. That expression of yours. You know the way sometimes a look or a moment can remind you of something altogether different. Well that's just happened to me. That look on your face brings to mind a book I once read. Many years ago. By that Russian guy, Alexander Solzhenitsyn. The one they made all the fuss about. Years in the Gulag and all. I bet you're surprised to know I've read a book like that. Russian literature. High brow. But there's a lot you don't know about me, Mister Smartypants. A lot that you've underestimated. I think it was called *Cancer Ward*, the book I mean. Anyway, in the one I'm thinking about, the hero of the story is strangely comforted when the secret police finally catch up with him. Track him down. Tap him on the shoulder. As if the pain of waiting for it to happen was far greater than the reality. Glad that he was going to be put out of his misery. So that's what I see in your expression. A look of resignation. And I'm a good reader of faces. I have to be in my profession. Even at a distance, in the half-light.

So this is how it will be. My two colleagues will appear on the steps behind you. You'll hear their footsteps. You'll turn around, see them standing there. The size and cut of them, and you'll come to appreciate more fully what's unfolding here. Get a real clear sense of the predicament you've landed in. I'm going to beckon you forward. No threatening gestures. Nothing unnecessary. Nothing that might create a scene. Just a wave of my left hand. You'll walk slowly towards me. Maybe you'll notice what I'm holding in my other hand. Your expression might change. Something akin to fear. I suggest you'll need to come to a place of acceptance. To acknowledge that this is simply the day that had to arrive. It all being no more than a matter of synchronicity, of timing.

Call me old fashioned, but the way I see it is you reap what you sow, my friend. And, if you'll indulge me to stick with the imagery, what you sowed in my field was worse than a crop of barbed wire. It hurt me, cut me to the quick, to harvest what I thought we were growing together. I'll show you the scars if you like. But you'll need to come closer. Just come closer.

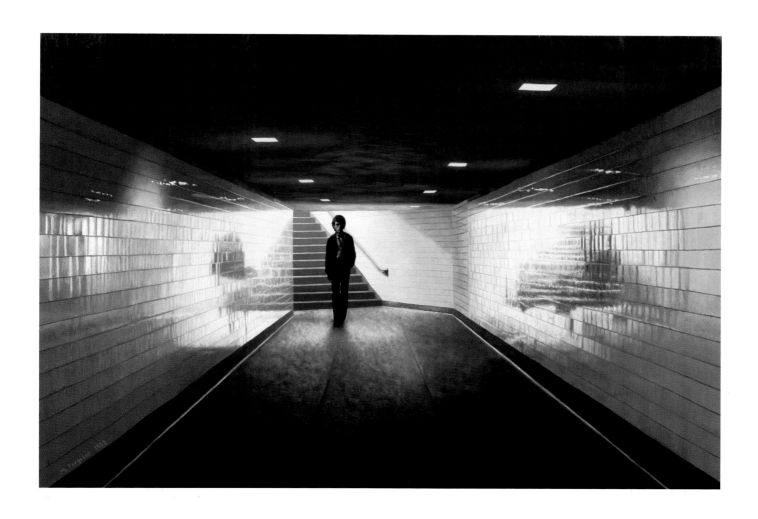

CENTRAL PARK NOCTURNE

oil on canvas, 2004
44 × 29 inches / 113 × 74 cm

And you will bring me something warm. Like a coat. Made of fur. And you will bring me something warm. Of leather gloves. From St. Petersburg. Once, leaning over Trinity Bridge, we watched the ice-skaters circling on the frozen Neva River in the dark November night. The Winter Palace. Princesses passing by on gilded sledges, happily unaware of the dungeon and the cold ricochet of bullets.

And you will bring me something warm. When our New York city sleeps. When all are in their beds. You will bring me something warm. Like soup. Like broth. Thick and satisfying. A pottage. Of peas and ham and mint. Seasoned and salted. Nourishing. For you will wish to see me nourished. Of that you'll want to be sure.

You will bring me something warm. To warm my heart that beats for you. Blood-red and vital. For the warm things you will bring me I will wait. With patience. In certainty. In assured and calm certainty. And I will hear your footsteps. Making the sound that only comes from footsteps in icy snow. And if I hear them not, for sounds are never certain. Then I will see them. Imprints on the virgin snow. Forming as you walk towards me. As I see you coming. Bringing something warm to me. And if I see you not, for sights are never certain. Then I will know it is you. By sensibility.

Here. Waiting. This crisp and hallowed night. Haloed lights. Diffused. Muffled. Unsure of what they illuminate.

That day we walked across the fjord in Fossheim. The ice cracking beneath our feet. To reach the other side. To scale the glacier. Gloved hand in hand. Unaware of the shifting ice-floe. The avalanche to greet us, that we, in part, had set in motion. Then rolling together, two baby cubs in play, tumbling and falling, laughing in our death throes. Entombed, enraptured, our faces frozen in the moment. Our breaths entwined. You whispered, your lips touching my ear. You promised you would hunt us a bear. Tear it open with your teeth. And we would climb inside its belly. Feel the fur against our cheeks as we crawl inside the chamber. Drifting to sleep in each other's arms. The world so white and soft and quiet around us. Unsounding. Soundless. Collateral. The snow. Deeper. More various than on these New York wintry paths.

In our park I wait for you. Hidden from the eye. Surrounded by the empty spaces of this nocturne scape. Where in times gone by we've waited for each other. In all seasons. For reasons aplenty. And I have time to wait. For time is what I have. For you to bring me something warm. The bear. Heaved along the icy track. To rip asunder. The cave for you and I to enter. Together. Nourished. Or else a scarf. To keep me warm. Of fox. Of ermine. For you will bring me something warm. When you come. This night. Bearing what you can.

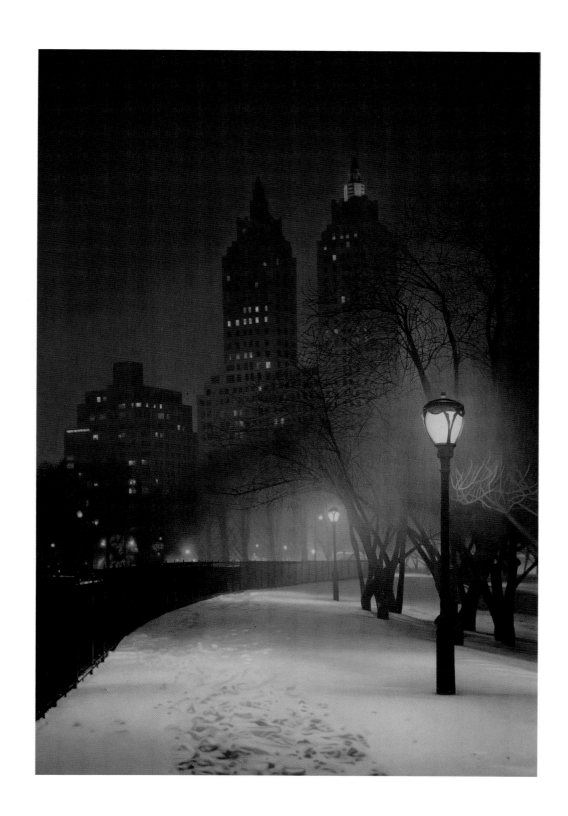

SHOE REPAIR SHOP

oil on panel, 2008
16 × 16 inches / 40 × 40 cm

'Yes,' the shoemaker says, placing the boot she's just handed him on the counter, 'unusual, for sure.'

But nothing more than that. He's well used to peculiar requests, having worked in the shop, man and boy, for nigh on fifty years.

'There was the time in the 1970s,' he continues, as he rummages around for the pliers, 'when a sociology professor from Columbia sent students along this street asking us to do all manner of odd things. This young kid comes into my shop, no shoes or socks. "Can you put a leather sole and heel on my bare feet?" says he.'

'And what did you do?' she says.

'I asked him how much was he prepared to pay.'

She looks a bit shocked, but his smile reflected in the mirror, reassures her.

'Ethnomethodology they called it. I like the word … ethnomethodology … it's got a nice rhythm to it.'

'What?' she says.

'Ethnomethodology …' he repeats, relishing the sound. 'He told me all about it, this kid. You try to disrupt the everyday world. To see how people react. Mr. Tang in the dry cleaners next door. His student came in with a muddy cabbage and asked him to clean it. That kind of thing. But I told my student there wasn't much you'd describe as an everyday world around here. It's getting disrupted all the time.'

Then he turns, pliers in hand, and examines the beautifully decorated boot. A surgeon about to perform the autopsy.

When she first got the letter from the attorney and then went to their offices to collect the old cowboy boot, she was intrigued. But, just like the shoemaker (and the dry-cleaner with the cabbage) she was not that surprised. Her great-uncle was a famous eccentric and she was his only surviving relative. Family stories abounded. Like the rides he used to take on the old steamers in the south, gambling away his gold. His prodigious skill on the stock exchanges. His parsimony, living like a hermit. Travelling in boxcars. A carpet bagger without a carpet. He'd appear at functions, mainly funerals. Tall and gaunt, in his ragged great-coat, grizzly beard and grizzlier greasy hair down to his shoulders. He wore a patch, just to keep one eye spare. And always the same cowboy boots, one of which the shoemaker was now wrestling with.

She watches him as he begins to free the heel from the boot. The sound and sense of it reminds her of the time she had her wisdom tooth extracted. And, like a molar being released, something falls from the yawning jaw of heel and sole and clatters onto the smooth wooden surface of the counter.

The shoemaker lifts the key by the tag and hands it to her. It is cold and heavy in her palm. The string is frayed and worn and the engraving on the metal tag is faded. She squints to read it.

'What does it say?' he asks.

'… Deposit Box 25 … Wells Fargo Bank … Dubois, Idaho …'

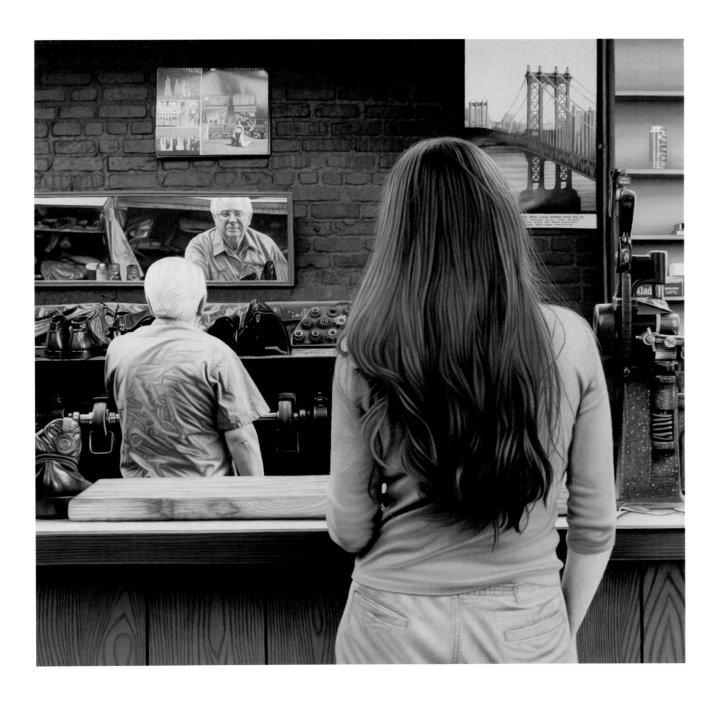

ATLANTIC CITY

oil on canvas, 1998
30 × 40 inches / 76 × 100 cm

She's something of an icon is Ruth. The famous sculptor, now in older age, yet with a mind and art still fresh as the tides. She who comes down to the beach each morning in rain, sun, hail, snow, or anything in between.

She stands at the water's edge and breathes in the horizon. Then she walks into the waves. Two or three steps onwards, then she plunges into a breaker. Under the shallows. Pressing her fingers into the shifting sands. She swims out into the steely cold water. Breaststroke. Ten minutes or so, rarely any longer.

Back on shore she dries herself with the towel she's left on the beach. Kneeling as the waves recede, she pauses. Then scoops up the wet sand. Cradling it, pressing it into a mould. With care, with intuition, she releases her grip and lets the silt flow, a sparkling stream runs riot. Grain sticks to grain, defying gravity, building upwards. Passersby stop to admire the towers and citadels, elemental forms and figurines taking shape. She smooths and crafts with all the care and precision that in days gone by elevated her art to the Tate, the Guggenheim, the Met and beyond.

Stretching stiff limbs, she looks up at the pier. Shielding her eyes from the glare. Sometimes she remembers, sometimes she forgets. Today she recalls the day, so many years in the past, when she and her lover stood beside the carousel, watching the yachts bob and tilt in the swell. It was to be their last time together. The end of a decade-long secret. The next day the papers ran the story they both knew was coming. He, the celebrity gallery owner, married into Westchester County money. She, the reclusive sculptor, bohemian, rarely seen in public and never interviewed. The press pack descended as one. The divorce lawyers picked through the carcasses.

Back in her studio she might look at the tattered postcard of the Bronzino print pinned high up on the door. The portrait that reminds her so much of he and she and the serendipity of their ever having met. But, just as likely, the thought and distant memory would have fallen away. Fallen as easily as the grains of sand from her toes as she walked barefoot up the hill to her sanctuary. Her mind filled with images of a sculpture revealing itself. The suggestion of form, of love, of sorrow. Of hope, of sustenance.

Meanwhile, on the beach, the tide licks at her sandcastles. Grains crumbling into the salty water. A trickle, a cascade, an avalanche and the tower topples. A tidal wave of fume flicks out its tongue and the city crumples in a heap, swept flat and wet by the next surge. Sucking back, pulsating as the water recedes. Momentarily. No sign that she was ever there. Ruth, the old woman of the sea. Who swims in the morning. Who children point to in wonder and bemusement. Who makes castles on the sand. Grain by grain.

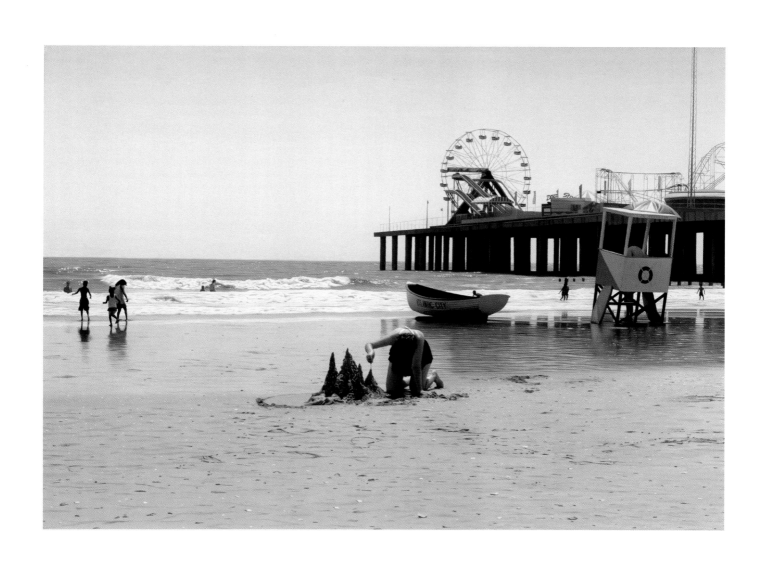

CONEY ISLAND SELF-PORTRAIT

oil on panel, 1989
20 × 30 inches / 50 × 76 cm

'This might be my only chance.'

Those were your words the last time we stood here together. Since that time, I've always come to this spot alone.

'But it was never part of the plan. What we're doing together.' I'd said in reply (or I said something like that, with the same sentiment for sure). As we looked across the water.

Today, there's a bit of a breeze. Tiny waves catching the light. Like the way Canaletto always painted them. Swift white brushstrokes to mimic the ripple on the water's surface. If he was here Canaletto would've liked the way the water is imitating his paintings.

'I love you. Simon,' you'd said. 'I want us to share everything. Everything life brings us.'

Then after all the tears. The sleepless nights. We made the decision. Though, as I said to you, right up to that morning, it was your choice. Your decision. It had to be. I said I would support you. Many times I said that. In cafes. In bed. On the train to the appointment. Yes, I said it was your decision. But, in case you hadn't got the message (my message) I also said it was never in our plan. Nothing we'd ever discussed. But if the truth were told, I'm not certain there ever was a plan for it not to be part of.

On that morning of the appointment, after we'd parted (you said you wanted to go alone) I came here to the boardwalk. I stood for hours. In silence. Looking across the water. Did I think of Canaletto? Were there waves? I can't quite recall. But I do remember a peculiar sense of lightness. Of relief. As if something had been given back to me. Something I didn't know I was liable to lose.

Today it is very different. What with all that has gone between us since. Today I feel a deep sadness. Guilt for a sin beyond sinning. Grief. Bereavement. Wondering how it might have been. How we may have been. Otherwise. I'll stay on a while. Looking across the water. Soon it'll be darkening and I'll meet you for a drink before the theatre. The Beckett revival. The one from the Abbey Theatre in Dublin that we've been looking forward to with such anticipation. The things we do together. It's one of many treats to each other. And after the show we'll have coffee and cake in one of our favorite cafes. Then we'll go home. Maybe we'll make love. With abandon. No need for precautions these days. Not since your operation. And we'll hold each other close as we drift to sleep. For we've been happy. Had happiness. Just the two of us. But I shan't tell you I've been to Coney Island. That I stood and looked for the Canaletto waves that might have turned back time. It'll stay my secret. The place where I connect to another future. A future that was never part of our plan.

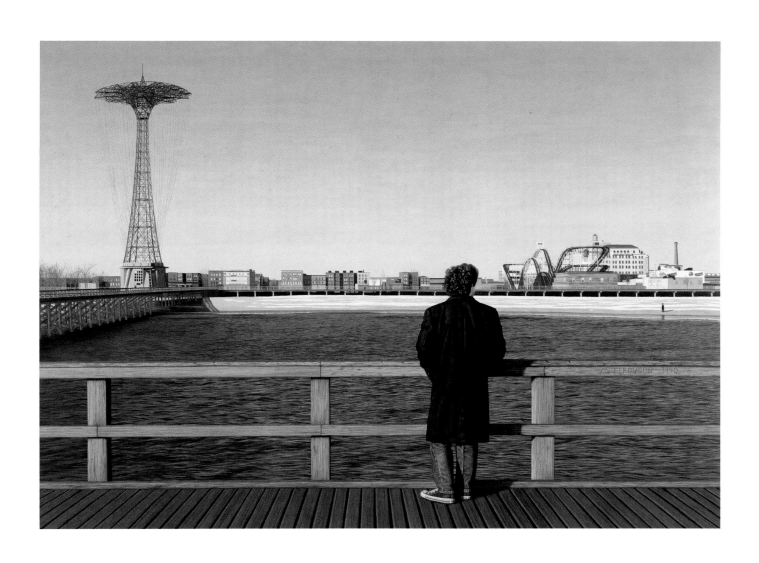

WOMAN IN CAFÉ

oil on panel, 2009
12 × 12 inches / 30 × 30 cm

No time now to finish the cake, or to order a second cup of coffee. She must move on. And quick. There it is; on page four. All the little details. The police had arrived at her apartment next to the Silver Bullet Bar, off Washington Street, Champaign, Illinois. "It is quite clear that those in attendance appear to have left in great haste. The television set was still on and a tap was running in the sink." Officer Brandon was reported as saying. "We are especially interested in questioning Ms. Hang who had recently taken a lease on the property and appears to have been the occupant. She was last seen drinking in a nearby bar, but no one knows where she is now. But we urge any witnesses to come forward."

She reads on, keeping her head down. Last night, in the motel, she'd cut her hair, even thought of dying it, but decided not to. An Asian with anything but dark hair might draw attention. And attention was the last thing she wants right now. She thinks of Janet Leigh at the traffic lights. And the Bates Motel. But she no longer has a mother to run to. Nowhere to go. Nowhere to hide. Instead of coloring her hair she bought a hat that she could pull down to shield her eyes. As she does now. Looking around to see if anyone seems to be noticing her. If anyone else is reading the paper. The news.

There in the middle of the page is her photo, with her parents. It was taken at their lakeside house, two summers ago. "Who would have thought such a terrible thing could happen," she reads, hearing the sound of the janitor's voice in her head. "Such a quiet, polite girl. Always said good morning and smiled. She was studying at the university. A very studious girl. Never caused any trouble. Parties or that sort of thing." In the following paragraph the reporter describes the scene. She finds it hard to focus on the words. Enough is enough. More than enough. She folds the paper, tugs on the front of her hat and stands up to leave. There, right in front of her, is the waiter. He looks concerned, surprised.

'Everything alright, Miss? ... Something wrong with the cake?'

'No ... no,' she says, startled; the strange way he seems to be looking at her. 'It's me ... I mean ... it's not the cake ... I just have to go now,' all but pushing past him, dropping the paper, reaching to pick it up, then thinking better of it. '... it's alright. Leave it ... on the floor ... I have to go ... now.'

The waiter watches her hurry through the open door and then, through the café window, sees her fumbling with the keys to the white saloon car parked directly outside. Carefully balancing his tray of dirty plates and cutlery he bends down and picks up the pages of the newspaper that lie splayed open before him.

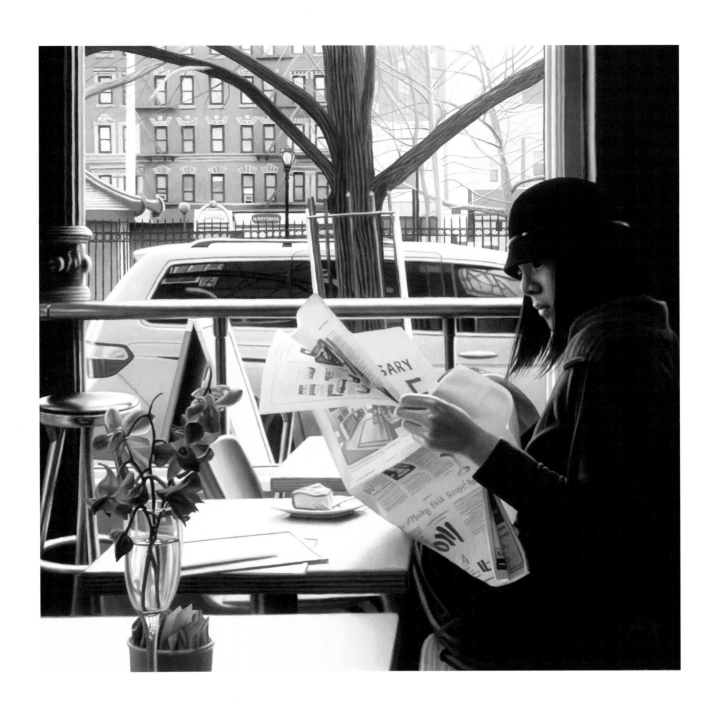

LATE IN THE DAY

oil on canvas, 2009
20 × 30 inches / 50 × 76 cm

PAUL and REBECCA FEEL the pleasantness of the sun on their faces. PAUL WATCHES a young couple pushing a stroller. HE WONDERS if he will still be alive on the child's first day at school. HE CALCULATES he'll be eighty-three years old. REBECCA SPOTS a seagull on the wing. SHE tries to REMEMBER its Latin name which SHE KNOWS she once knew. HE FEELS a sharp pain in his chest. SHE HEARS a tinny ringing sound deep in the cavity of her right ear. HE SAYS 'I heard on the radio that Karl Malden died.' '… Oh,' SHE SAYS '… I thought he'd died already.' SHE SCRATCHES the back of her neck. PAUL LICKS his dry lips.

… … … REBECCA FEARS something unknown … … …

PAUL WHISTLES a tune. In unison, REBECCA SINGS gently under her breath 'the reason is … because something's happened to me …' … and they BOTH RECOLLECT the bald black man in the spotlight at the Café Carlyle. PAUL SMELLS the Jamaican rum he used to drink when they went dancing and SHE HEARS the piano keys tinkling. 'Is he dead?' SHE SAYS. 'Who?' HE SAYS. In HER MIND'S EYE SHE SEES the face of the pianist, but can't CONJURE the name. PAUL NOTICES a police helicopter in the distant sky and makes a MENTAL NOTE to put the new car in the garage like he'd promised he would. REBECCA FRETS about her eldest son and his impending redundancy. 'Bobby Short,' HE SHOUTS, excitedly. 'Ah, yes. Of course,' SAYS REBECCA. '… still got a couple of grey cells between us.' They BOTH SMILE, REBECCA for what she just SAID, PAUL for what he'd RECALLED. SHE SAYS 'Lovely and warm still.' HE SAYS 'That's why we came here.' 'Yes,' SAYS REBECCA. 'For the climate,' SAYS PAUL. 'Not just for that,' SHE SAYS. 'No,' HE SAYS, 'not just for that.'

… … … REBECCA FEELS a sense of loss … … …

They BOTH WATCH a man and woman saunter by, arm in arm. REBECCA RECALLS a walk with Paul on the pier at Coney Island and the sounds of the funfair … when they and love were young. PAUL WORRIES that he will die before REBECCA, leaving her alone. HE BELIEVES it is he who will cope better with widowhood. 'Getting later,' SHE SAYS, '… all of a sudden.' 'Hmm …' SAYS PAUL. 'Let's head back … soon.' HE WONDERS if he'll eat the cold chicken in the fridge. SHE THINKS the dog needs a bath.

… … … They BOTH KNOW they're loved … … …

And they BOTH KNOW that when they get up to go they will REACH for each other's hand and FEEL the TOUCH and WARMTH of each other's fingers as they entwine. PAUL and REBECCA STAND UP from sitting. REBECCA TRIES TO REMEMBER when she last took a swim in the ocean. PAUL SINGS WITHOUT REALIZING HE IS SINGING 'I like the likes of you … I like the things you do …' REBECCA REMEMBERS WITHOUT REALIZING SHE'S REMEMBERING a dance in a dance hall and the swish and swirl of her dress.

… … … TOGETHER they WALK on. … … …

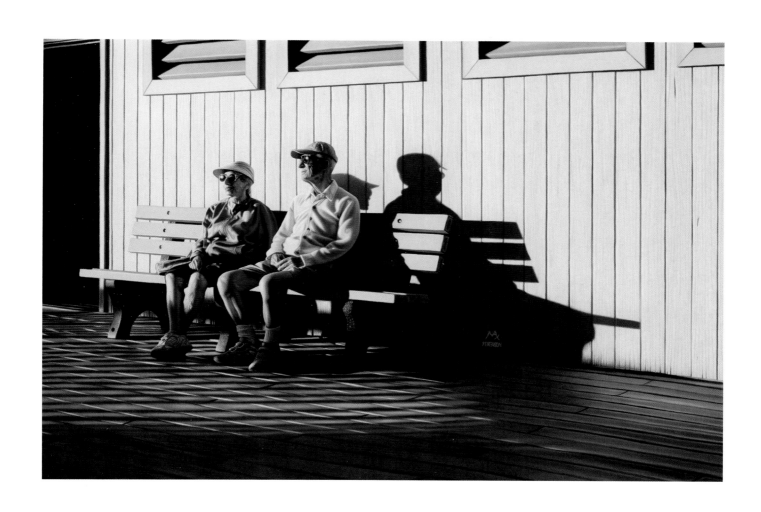

BILLY'S TOPLESS

oil on panel, 1991
20 × 30 inches / 50 × 76 cm

Monika Beerle stands across the street in the rain. Her dreams of the Mariinsky and Martha Graham zipped in the hold-all at her feet, along with the jumble of glittering tassels, pink ballet shoes, G-strings, woollen leggings, and stiletto heels. She notices a young man lingering on the sidewalk, pacing back and forward, pausing then moving on.

That afternoon, Bill Pell, perched on a stool, rolling the stub of an unlit cigar around his mouth, watched (with seeming detachment) as she pulled her powder-blue angora sweater above her head, as she carefully rearranged her ruffled hair. She looked the old man in the eye as she reached behind her back to unfasten the clasp to her brassiere. Momentarily she cupped her breasts in the lacy material. She reminded herself what Rakowitz had told her. That this was easy money, no lap-dancing, no touching. They were stoned and she had said yes. Even the next afternoon when they came to, she'd said yes. Rakowitz'd seemed too excited, too strange. But even now, at this moment, she was unsure. Bill gestured. She looked past him. At the tiny stage. The chairs in circular rows. The Sterno cans on the bar. There was a smell of lasagne and of something else, burnt; another flesh. 'Small, but pert,' he said. 'But no implants. No implants at Billy's.' She looked down at her bare breasts, her nipples strong and protruding in the cold. She felt sorry for them, for their being exposed. For what the night would bring.

The young man folds his umbrella. He looks up and down Sixth Avenue, then hurriedly, purposefully, pushes open the door and is sucked inside. Monika checks her watch. Ten minutes to her debut. Her opening night. Her contemporary dance. The rain falls ever steady, somehow adding to her sense of self.

In their shared bedroom on Avenue C, David Rakowitz lights another joint, stares up at the mold on the ceiling and summons his calling, his Church of 966. He draws deeply, the marijuana tickling his mind and conjuring images of his lover tantalizing strangers, titillating, holding back, promising, then denying. 'They shall hate the whore,' he says between the smoke-rings drifting skywards, 'and shall make her desolate and naked, and shall eat her flesh, and burn her with fire.' Hot ash falls onto his bare chest. He flicks it away, his skin tingling from the heat. 'Revelation. Chapter seventeen. Verse sixteen,' he hisses, remembering the words from the preacher in the whitewashed church in Rockport, Aransas County. He reaches under the bed and feels for the butcher's knife. He grasps the cold metal, tempting to slice the skin of his palm. Closing his eyes he dreams of soup and meaty broth and shadowy men licking their lips. Famished, then replete.

In the early hours Monika turns the key in the door to their room. 'David,' she calls. She is tired and cold and wet and craves comfort, 'are you there?'

Somewhere, from the dark, the rooster crows.

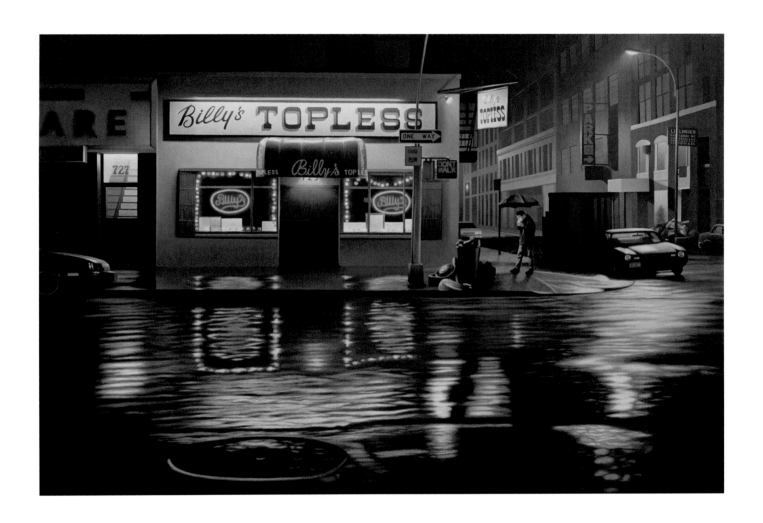

ANDREA IN FLORENCE

oil on panel, 1979
16 × 20 inches / 40 × 50 cm

Andrea looks out to the horizon. A golden sliver curving a line between heaven and earth, tracing the setting of the sun. A tinge of pink. Evocative of something unreachable, something intangible.

Andrea was six the first time her grandmother spoke of the hidden gold. Andrea, snuggling on her grandmother's lap, listening to the crackle of the fire, smelling the broth on the stove.

'… the ogre chased the princess through the forest. She hid inside a mulberry bush. When the ogre thundered by she dug a hole with her bare hands in the soft earth. She buried the bag of gold. Deep underground. When the princess looked up she saw a snow-white stallion drinking from a stream. She climbed onto the horse's back and they galloped away to the palace by the lake.'

Andrea imagined bluebells on the forest floor and the wind rippling through the horse's mane.

Andrea was fourteen the second time her grandmother spoke of the hidden gold. Andrea, sitting with her grandmother in the kitchen, hearing her father, drunk and forlorn, snoring in the parlour.

'… we knew the rebels were close … refugees poured through our town … terrible stories … fear in their eyes. I buried the gold near the graveyard … took your father in my arms … hid in the forest …watching as they burnt the town to a cinder. They set up camp in the ruins. So we fled north to my uncle's village, escaping days before the warlords sealed the border.'

Andrea imagined a baby's hungry cries and a mother's desperate tears.

Andrea was twenty the third time her grandmother spoke of the hidden gold. Andrea, waiting at the station with her grandmother, the rumble of the train coming closer.

'… I've kept the gold from your father. For he'll drink gold or he'll drink dust. Drink is all he knows to do. But never blame him … the second war … the one we thought would never come … destroyed him. And he'll keep you trapped in this sorrowful village if you let yourself be kept. The border has opened at last! I'll live out my days with him … a mother's duty, not a daughter's. You must seek a new life.'

Andrea imagined how it might be, away from all she's known of barren fields, of empty days.

When the train passes the old frontier, no soldiers in sight, Andrea's grandmother closes her eyes and sleeps, peacefully. Knowing that tomorrow they'll reach the place of her birth. Knowing that she'll find the spot and dig up the gold. Knowing there's a man she can trust who will give them a good price and keep safe their secret. Knowing that she will give her granddaughter all the money and make her promise not to come back until she has found a life of her own.

Andrea feels the warm breeze on her cheek. Her gaze is fixed on the last ray of the sun. A pinprick. A cypher. A pointer to days to come. An evocation. Reachable. Tangible. Hers to grasp.

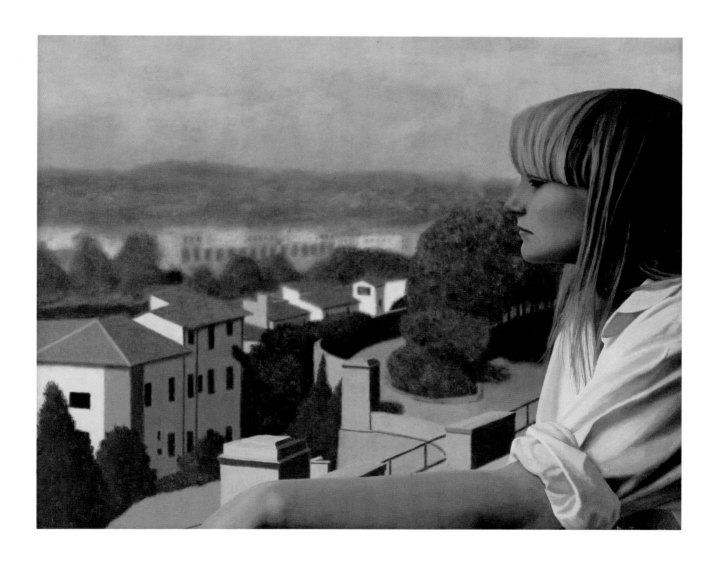

TAXI DRIVER II

oil on panel, 2005
6 × 9 inches / 15 × 23 cm

'He's changed lanes!'

'It's okay. Trust me. I'm all over it. If he takes the filter to the airport then so can we. Once we get through this tunnel.'

'Don't lose him.'

'Take it easy. I won't lose him. I've got this under control. Just relax.'

Looking in the rear view mirror I don't like what I see. He's sweating. Dabbing his forehead with his handkerchief. He's panting. His eyes are bulging. Bloodshot. Maybe I should've heeded to my instinct after all. I had a bad feeling as soon as he banged on the window, with his "follow that car … the black one," waving two hundred dollar bills at my face "whatever it costs … but go now!" Pointing at the black car waiting for the lights, fifty yards up the road. Pulling on the back passenger seat door handle that I'd locked against all the Brooklyn crazies.

You get a sixth sense in this job. I'm sure it's the same in other lines of work. But for me it's a feeling in the back of my neck. Like some kind of danger barometer. When I wound down the window to this guy the needle began to jump. It wasn't just his body language: the agitation, the high anxiety. Or the pitch, tone and tempo of his voice. Something else altogether. What the hell I thought. It'd been a bad week. The fuel pump had finally blown, so I'd had no work Wednesday and a two-hundred-and-eighty dollar garage bill. Today I'd

waited two hours at JFK for a thirteen dollar job. The luck of the draw they say; but that made three unlucky airport draws in a row. To top it off I get a call from Maxine while I'm waiting at the taxi-rank telling me if I miss another childcare payment I'd be hearing from her lawyer. My ear was still buzzing from her abuse when I get the bang on the window.

Driving along I keep a careful eye on him. And another on the black car. And a third eye on the road. But I figure he needs me and so long as the black car stays on the Van Wyck Expressway it'll work out okay.

There's an old hymn on the radio. One I recognize from church days. Then the preacher comes on. He talks about life's journey. The stresses of the modern world. "Each one of us has a unique pathway," he says. "Look to the scriptures. Proverbs 3:6."

A hundred yards ahead, the black car takes a sudden left off the freeway, before the airport, onto an unlit slip-road towards the cargo warehouses.

'Turn!! Turn!!'

He's leaning over the front seat. His breath steaming in my ear. In the mirror his face is huge and red, veins bulging in his neck, and eyes looking like something from the devil.

'Follow that car! You! … Turn! Don't mess with me!'

"… Seek God's will in all you do and he will show you the path to take."

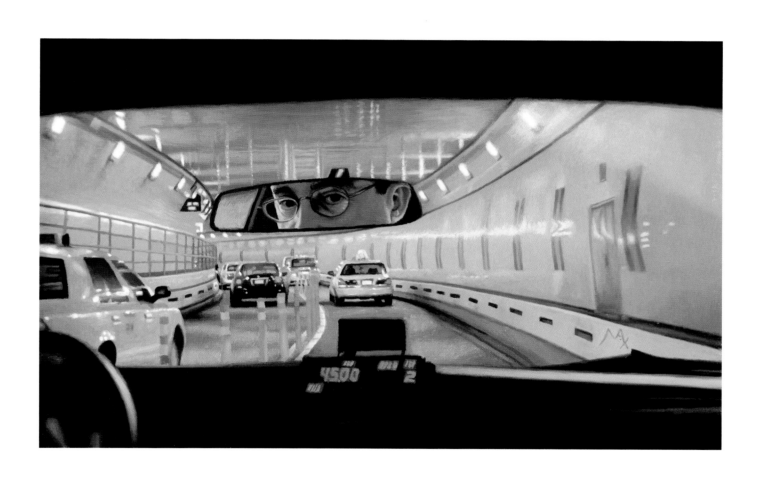

EAST 72ND

oil on panel, 2015
11 × 14 inches / 28 × 36 cm

'Hello … Jerome.'

'… eh, yes … who's this? … what time?'

'It's me … John Kearney … you told me to call, whatever the time.'

'… oh yes, John …'

Jerome Robson knocks over his glass of water as he stretches to turn on the bedside lamp.

'Damn!'

'… What?'

'Not you … the glass … it's okay.'

Jerome lies back on the pillow, the sound of water dripping on the parquet floor of the bedroom. He lets the phone rest on his chest, the plastic cold and hard on his skin. He turns his head to see the digital alarm clock. Three forty-six.

In two weeks' time it will be their fifth wedding anniversary. He made all the plans almost a year ago, as soon as the tickets went on sale. He's kept the big secret from everyone. Well except from his mother, who had to know. She's to be the one to look after the twins for the long weekend.

It was in New Orleans that they'd met and had fallen in love and now they'd be going back for the Jazz Fest. He even booked business-class flights on Delta. Champagne all the way. Child-free days. Child-free nights!

Back then he was playing at Sweet Lorraine's Jazz Club on St. Claude Avenue. She was studying architecture at Tulane. He'd spotted this drop-dead gorgeous blonde at the front of the small Tuesday night crowd looking dreamily up at him. She always maintained it was his super cool saxophone playing that hypnotized her. He'd say it was his chiselled good looks. She said her name was Juliet. He said he would die for her. And so it was that they fell for each other from the get-go. Crazily. Totally. Even the shock of the pregnancy they turned into an affirmation: a sign of the inevitability of their union. They got married and moved back to New York. He got a job teaching music in high school. Once the girls were old enough for kindergarten she picked up her studies at The Cooper Union.

It was only in the last couple of months he felt things had shifted. She stayed late at school. Missed the kids' bedtime. Even called to say she'd be sleeping out (at a cousin's or friend's) after a movie or dinner date. Most of all she talked too much about Professor Blackwood and the research job he was lining up for her. And she was distant, in a way that was hard to define. And always too tired for Jerome. Turning her back on him as soon as they settled into bed for the night.

It was his best friend Raymond who suggested talking to his brother-in-law-cum-private-investigator, John Kearney.

'Jerome … your wife's with Blackwood … an apartment building on East 72nd Street … since last night. It's nearly four now. They've not come out.'

'…'

'Hello … Jerome … you there?'

Jerome curls up on the bed. The phone limp in his hand. The voice marooned. A pain far deeper inside his chest than the place where his heart resides.

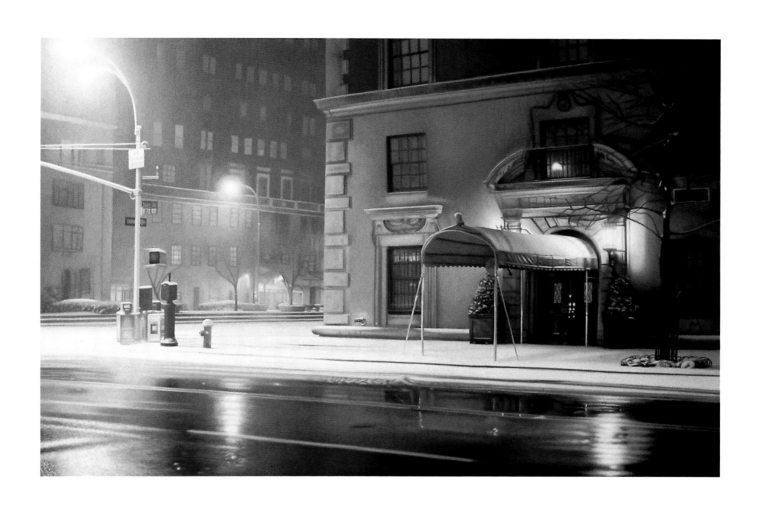

COFFEE

oil on panel, 2015
27 × 27 inches / 68 × 68 cm

Ruth wants to say 'You promised.' She wants to say 'you break my heart.' She wants to say … something. But she knows this is beyond words, beyond talk.

There he stands, Jacob, her big brother. The hero of her girlhood. Her protector, her playmate. Her erstwhile roommate and confidante. He's leaning against the door frame, as if he might as easily fall back into the street as step into the café. He is trying to keep his head up. Struggling to get the lighted cigarette to meet his lips.

What did the guy read out at that one NA meeting she went to with him? That young girl off the street telling her story of crack and selling her body at thirteen and trying to get clean at fifteen. The guy at the top table had said something about we addicts, we junkies, we alkies, being peculiarly qualified to help those who stumble and fall in this business of meeting life. It was deep mid-winter, but Ruth was so happy that evening, so hopeful. Sitting there with her beloved brother. To sense, to dare to believe, that there might be a chance to turn their nightmare into a fairy story. To pick up the pieces of their shattered family. That there could be trust again, peace again. Jacob seemed so positive, so lit up. That cold New York night in a draughty church hall, with this teenage girl telling her story of 'experience, strength and hope.'

Ruth wants to say 'you know I'd die for you.' 'I've loved you until the hurt's killed me.' But she can't. For all the words ever to be said, she's said. In coffee shops, in homeless shelters, in rehabs and detox wards.

She wants to scream. She wants to howl. She wants to cry out. For her pain. For the pain of their parents, who have aged and splintered before her eyes. Watching their golden boy, their special son, tear his life apart for over a decade. The family joke about Jacob's ladder to the top, to any success he chose, turning to dust as he crashed from rock bottom to rock bottom.

Ruth doesn't need to see the quart of Jack Daniels in his jacket pocket. Nor the gram of amphetamines secreted in his sock. She can tell by the look in his eyes. The light extinguished. The window shut.

She sighs. A sigh of grief, of loss and of sadness, of tired exhaustion. And what comes to her mind, what strikes so heavily at her heart? The feel and weight of her earrings. So ironic, so perversely appropriate, that she wears them on this particular day. The very earrings, the ones she cherishes so. The ones that Jacob gave her on her birthday just gone. When he proudly told the family that he was one year clean and sober. 'Here,' he'd said, as he kissed her on the cheek, 'for you, for all you've done for me, all you mean to me.'

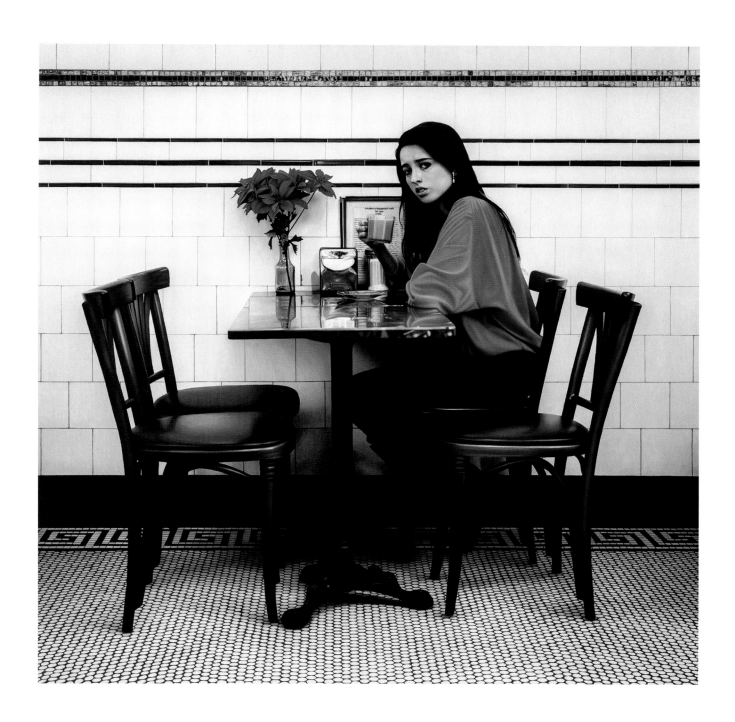

MR. GORDON

oil on panel, 2002
16 × 20 inches / 40 × 50 cm

The lines he is trying to remember. From the lectures he delivered all those years ago.

"… this long littleness of life." That's part of it. And "… being magnificently unprepared." Yes, that's it. "A young Apollo, golden haired …" Then something else, something about (he can't quite grasp it; can't quite recall the line or the link) … "magnificently unprepared for this long littleness of life." Something along those lines. Brooks or Auden. One of those First World War poets. Those who died far too young. Trapped in mud and trenches. Life and hope and wondrous thoughts to be brushed aside, extinguished, before they had the chance of a beginning. "Standing on the edge" … or was it "the verge" … "of life"? He looks across the river. The changing horizon. The gleam of glass and steel. The sheer height of it all. But the grass still smells of grass. The wild flowers and buds on his favorite tree ever-faithful still.

When he gets home after his walk in the park, the springtime blue waters of the East River shimmering in the milky sun, he reaches out for his old anthology of war poems to seek out the memory. 'Ah, here,' he says and begins to read the poem aloud to his wife. Then he remembers she's no longer here. Yet he continues reading. Still out loud, but more to himself. For he loves the sounds of the words. He sits in his weathered armchair "still and contemplative in living art" (now where's that from: Blake? Wordsworth? Dryden?) and drinks his late afternoon cup of lemon tea. And soon, contented with his thoughts for company, he doses, as he's come into the habit of so doing.

As dusk intrudes, casting a shadow on carpet and wall, he rises, slowly, deliberately, from where he's been resting. And as he moves to draw the curtains and turn on his reading lamp a snippet of his dream returns. He was in a room. Faces of friends appeared. His wife amongst them, and even his younger brother who drowned so sadly, so tragically. And on each of their foreheads in beautiful script was a date. A day. A month. A year. And in his dream he says 'Then I must have a date on my forehead. One I cannot see.' And all the faces turned to him and his wife said 'Yes, my darling, a date. You too.'

And in switching on the light and sitting back in his chair the trace of the dream disappears and he forgets that he'd ever remembered it. He picks up his book. "Francis Cornford. What a lovely mind to pen such words. To write about a fellow poet who died as young, as unbeknownst to Cornford, would be the fate of his own beloved son, John, on the fields of Catalonia."

He sighs. "… from whose bourn no traveller returns …" Then smiles. Happy that he knows for a certainty the quote is Hamlet, Act Three, Scene One, and the play is by William Shakespeare. "Born 1564, died 1616 … maybe."

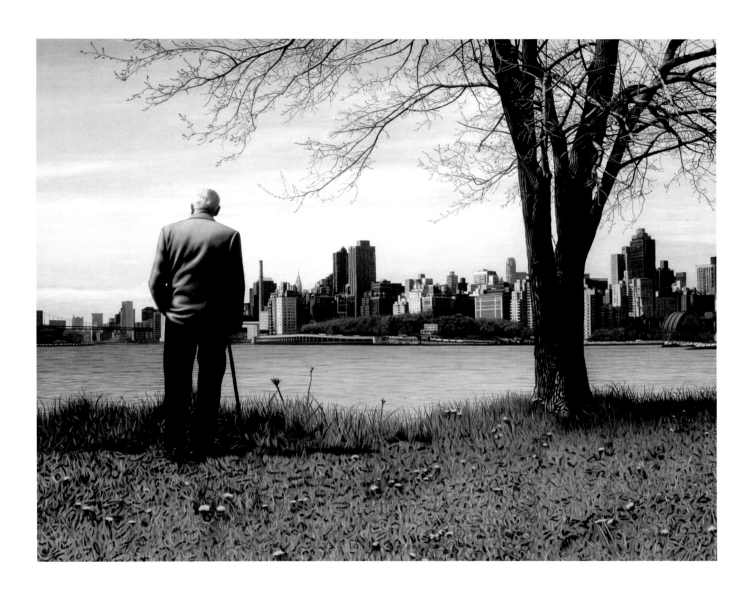

HANDBALL PLAYERS, CONEY ISLAND

oil on canvas, 2002
11 × 14 inches / 28 × 36 cm

Who knows? A gang thing? Some crazy random guy? A loner? Just one shot. That's all it was. Hit Dyson right in the temple. He dropped like a sack. With the ball in his hand. Still tight in his grip as he lay on the ground. When they told his grandmother, who's raised him since he was a baby, she wailed. She howled and beat the sides of her head with her fists. How? How? She screamed. No, no, she cried. Why … why … a good Christian boy … please Jesus, Mother of God, please no.

It should never have happened. He wasn't into handball. Basketball was his game. In fact, basketball was pretty much his life. It was only because Tyrone said that Marlene watched the boys play handball that he decided to join in. To show some skills. For he'd a real thing for Marlene, ever since third grade. To seal the deal he'd heard she'd broken with Jackson, what with his brother and the pending meth charge and her old man warning her off. So, maybe he'd be in with a chance. Maybe even lose his virginity before school breaks up for the summer. Now there was something to dream on. Almost as exciting as his basketball scholarship to Missouri that he'd be hearing about on the twenty-fifth of next month. Sometimes, at night, he'd weigh up what he'd want more. His first real sex before the summer school break? Or the basketball scholarship? Both please, Jesus (and if it could be Marlene for

one and Missouri for the other, that'd be just perfect). Just before the bullet, just before it all came crashing down, Dyson played a great shot, looked up at Marlene and she gave him the look he'd been waiting for, waiting for all his short life.

Kids from his school pinned messages and ribbons, flowers and keepsakes to the fencing of the handball court. The following Saturday a rally took place along Surf Avenue to protest at all the violence in the area and to demand an end to the drug dealing. No one was ever convicted of Dyson's murder and no one responded to the call for witnesses. Maybe it was just a random act of violence in a world where violence is so often calculated and targeted.

But it's endlessly strange how life has a habit of turning out. Like for Jose Mendes, from Camden, New Jersey, who if events had turned out otherwise would have joined his uncle's garage business and given up on his dreams. Instead he took up a basketball scholarship to Missouri, officially vacated by a boy who, "due to unforeseen circumstances was unable to enroll". The day before he left home, his grandmother, with tears of joy in her eyes, baked a milk cake to celebrate the first Mendes ever to make it to college.

Back on Coney Island, Dyson's grandmother cried herself to sleep, just as she would do every night for the rest of her life.

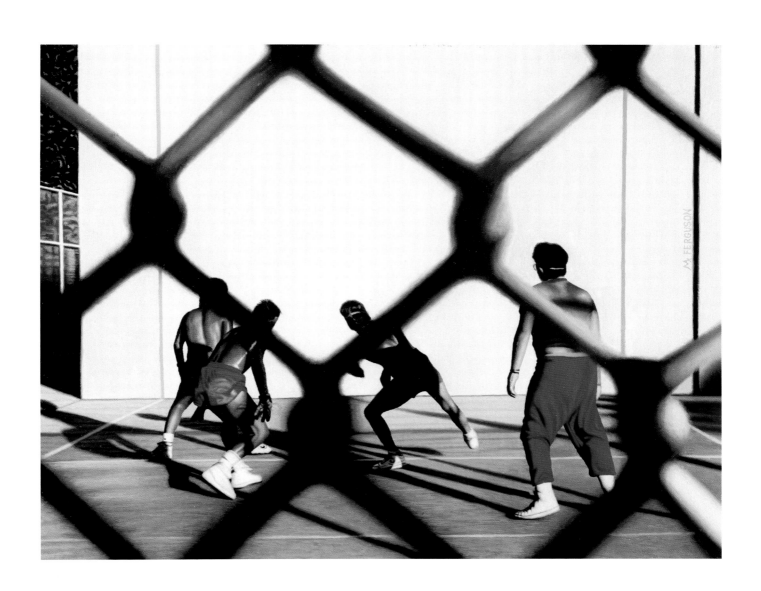

MOTHER AND DAUGHTER

oil on canvas, 2013
30 × 42 inches / 76 × 106 cm

All I can say is '… it's hard … what with all that goes with it. All the history. All that's happened since.'

I'm lying on my back. Looking up at the ceiling. The familiar contours and cracks. The single thread of a cobweb waving at the behest of the fan that hums and circles. Dr. Daniels' voice is detached as always: far away yet close at the same time. There's a tiny pause. The cobweb rises then falls. I keep my head still, my sight fixed. For fear of giving something away.

'I want you to be that little girl. With her mother. On the pier. To feel the sun. To hear the waves breaking on the shore. The seagulls soaring in the air. Can you do that Dorothy? Can you be that little girl all over again?'

The clock ticks. Out of my sight. But Dr. Daniels knows the time. Where she is taking me. How long we have to get there.

'Close your eyes. Dorothy. You deserve to be that little girl.'

And I do. And I want to. I so want to. To find that anchor. To learn another way to tell the story. To rewrite the narrative that has become so heavy and loaded in the repeating. So I close my eyes. Against the fan. The ceiling. The precious thread of dust.

My first time ever at the seaside. I've just begun to walk. With my new leather shoes that I'm so proud of, even though I'm yet to know what pride is. I'd been gazing through the struts of the pier. Scratching my nail at the soft wood. Licking my fingertips to taste and chew the salty woody grits. I look up at my mother who is bent forward, smiling. Her darkened silhouette partially blocking the brightness of the day. As she moves the light sprays around her as if she's being showered by sunbeams. I reach up to her, stretching my arms. Standing on my tiptoes. My head held back in supplication. She swoops me up and the sea and the sky swing into my vision, all blue and watery and brilliant. She holds me close and kisses me on the forehead, leaving her lips pressed against my skin. I feel so held. Warmer than ever. Her smell. Like nothing else. The sense of her. And there's something about the vast expanse of the sea. The huge canopy of the sky. The way it all meets yet drops and folds into one. And the gentlest of breezes, the vague sound of distant birds on the wing. She nuzzles her lips close to my ear and whispers words I know are of love. And we are the world. And in that moment, that real moment that can never be taken from me, there is no danger. No fear. No disappointment. My mother was there that day. On the pier jutting out into the bay. Her breath on my skin. Holding me close, pointing to the horizon.

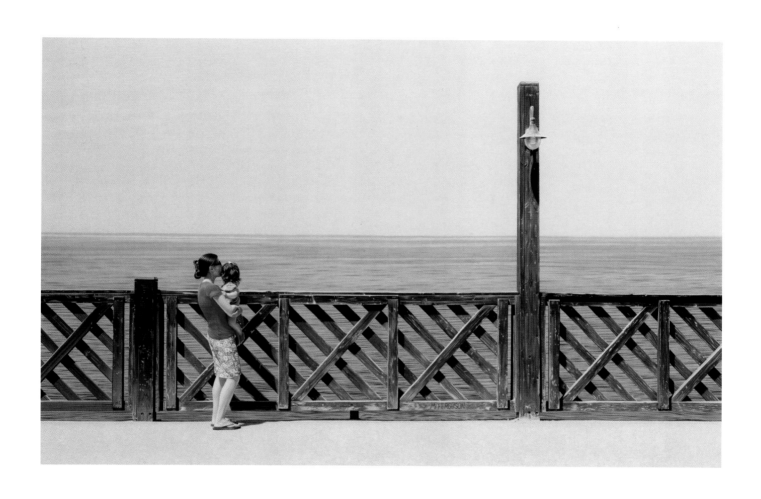

PAGEANT BOOKS

oil on panel, 2009
12 × 12 inches / 30 × 30 cm

This could just as well be a history lesson. This library, an ancient relic. A museum. A mausoleum of brittle pages.

Such are the thoughts of David Thompson, the school's librarian as he gathers himself to address the class. He turns on the slide projector. The one he keeps in the cupboard. Part of his private war against "new technology". When, forty years ago, he'd raised funds to bring the machine to the school (with its fifty-slide capacity carousel and its remote control) he was deemed an innovator. Now the children (and staff, behind closed doors) mock this dinosaur in their midst. This ancient wizened man who bans Smart Phones and IPads from the library. Who allows books to pile up on shelves. Out of order. The Principal, a kindly, not unsympathetic man, has indulged Thompson's war of the words. But soon the librarian will be gone. Retired. Canute with no more tides to push against. To be replaced by a media resources officer. Where a love of books will not be an essential qualification for the position.

'Settle, children,' he says as he turns out the light.

The carousel rotates and clicks at his bidding. A picture appears on the screen. Amplified.

He waits. The hum of the projector, the darkened room, the single beam and singular image quietening the class.

'What do you see?' he asks.

'… … …'

'… … …'

'Celia … tell us what you see.'

Celia is a sensitive twelve year-old, whose mother is a potter and bright spark in the idling engine of this small Midwest town.

'A woman … in a bookshop. Looking for something … in the book she's holding.'

'… … …'

'Maybe it's the wrong book,' says Raymond, whose father, now unemployed, was the manager of the town's only bookshop until it closed nine months ago.

Charlie Howson (who never speaks), who wishes he'd a different name, who wishes he didn't have pimples, who wishes he didn't have to hide behind his fringe, who wishes his father wasn't a drunk, who wishes his brother wasn't in juvenile detention, hears the sounds of the teacher, the murmurings of his classmates. But it's the voice in his head that commands his attention.

I'd be tall and handsome. I'd be sitting at the table sorting through the jumble of books. I'd own the bookshop. I'd ask the woman what she was looking for. In her fine coat. Her straight blond hair. She'd look at me. She'd say the name of a book. I'd know it, for this is my bookshop. She'd be impressed by me. I'd find the book she is looking for. She'd smile. She'd be happy. She'd let me hold her hand. She'd let me love her.

David Thompson turns off the projector. Switches on the light. He looks out at the class of faces. His life's work nearly over. And, like in every classroom, he thinks the thoughts of every teacher. Have I ever made a difference? Ever touched a heart? The buzzer sounds. The children stir, waiting to be dismissed.

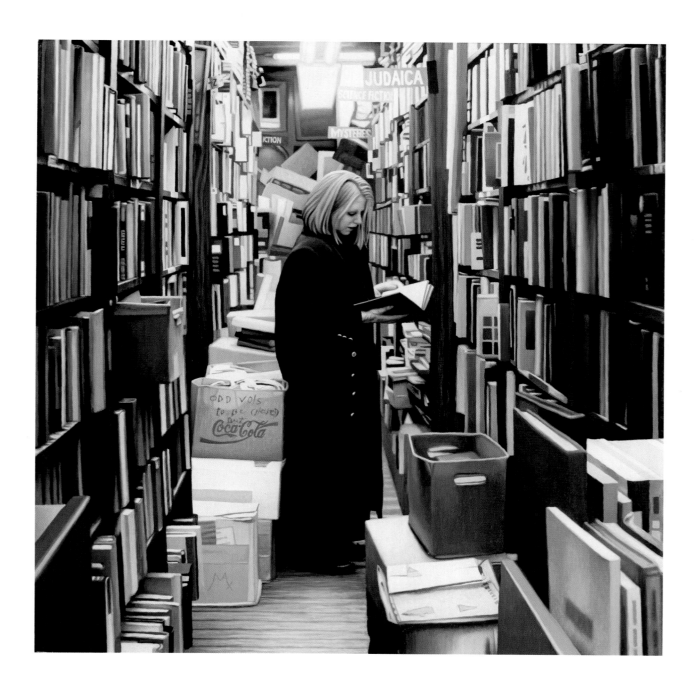

MY FATHER IN KATZ'S

oil on panel, 2005
16 × 20 inches / 40 × 50 cm

'What's up with Larry?' says Kitty, filling the salt-cellars at the counter.

'Not sure,' says Charlene, looking over to Larry sitting at the table he's occupied most mornings for twenty-odd years. '… Something's gotten to him … just staring … it's not like him … not at all.'

As soon as the Skeleton couple (as he came to call them) moved into the apartment above him, Larry sensed trouble. The look of them. Ragged and skinny, nicotine stains and Wild Turkey breath. Then the furniture they hauled up the stairs. The type most folk left out on the street. And the Skeletons were not your docile-heroin-type of junkie. Rather, the Skeletons were your wide-awake, music-at-all-hours, scary-friends-in-the-hallway, crazed methamphetamine-type of junkie. But Larry believed in live-and-let-live, so he tried to be neighborly. Early on, passing on the stairs, he smiled at Mr. Skeleton and held out his hand. Mr. Skeleton pushed by, clutching something close to his chest. Shortly after, Larry met Mrs. Skeleton on Eldridge Street. It was a nice spring day. Again he smiled (as he was prone to do whenever he met a neighbor or friend) and was about to say something (like were they settling in okay? or what a nice day to be out and about) when she snarled and barked. 'Keep your fucking dog quiet, you dog.' Larry was shocked by that incident. Not that he told anyone. Not even Kitty and Charlene at Katz's. He might have told his mother, but she was twenty years' dead come April. But the look on Mrs. Skeleton's face and the nasty words kept him awake that night. Scout curled at the end of his bed. The sounds and the fury overhead. The endless drone of the bass from the stereo. Scout came to sense things had changed for the worst. He'd taken to howling around dawn, often at the same time that the Skeletons finally called it a day. Then they'd bang on the floor and holler through the window. Obscenities. Threats. As if it wasn't themselves that had kept the neighborhood awake most of the night. And Larry would try to keep Scout quiet, but it'd only make him howl all the more.

Then this morning Larry let Scout out into the yard as he always did. There was Mr. Skeleton with a baseball bat, smashing the bins. Mr. Skeleton turned. The wildest, angriest look in his eyes. 'That howling mongrel,' he screeched, raising the bat above Scout's head.

When Larry pushed Mr. Skeleton he flew backwards as if weightless. In falling, his skull crashed against the corner of the wall. A sickening thud. Lying, sprawled and splayed, blood trickling from his nose and ears. Larry had once been a paramedic and knew a corpse when he saw one, even a Skeleton.

'I'll ask him,' says Kitty, putting down the jar of salt.

'He's the private type, is Larry,' says Charlene, 'you know that.'

'So am I,' says Kitty, walking over to where Larry sits, '… but everyone needs a shoulder.'

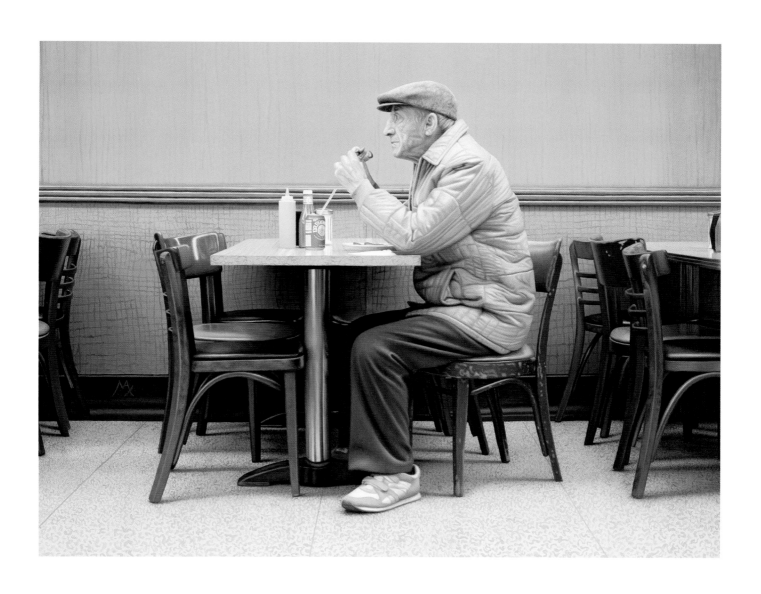

CHESS PLAYERS, WASHINGTON SQUARE PARK

graphite on paper, 1990
14 × 22 inches / 36 × 56 cm

I like the watch indeed I do but first five dollars from you who's read the books will lose on time your little flag'll fall so sad and I'll sigh and say you would've won but for the time what an enemy is time you play such a strong game never in a long while have I met with such imagination against my Sicilian defence you read the game so well but for time you would've won but I must hold off for now even though you haven't seen the fork I'm building on F4 that I could spring in three moves but I'll ignore it and let you think I don't know the Alekhine Capablanca game you're copying trying to copy and the A3 G3 reply for if I do you may not wager your watch when I suggest it having seen the only bill you've in your threadbare wallet is your five dollars and I reckon I could get sixty dollars from Oppenheimer's pawnbrokers on 122nd street for such a watch and your friend in the hat like your hat has a keen eye and I fancy will want to take on this Macedonian Grandmaster would like to try a battle of wills but I've read all the books you two have read have played all the games you two have played and can read your minds and will take your five dollars and all the notes your friend wishes to hand me five dollars for five minutes the minute hand is all that counts then your watch and when I go to Oppenheimer's and get my money I'll walk to Ed's Diner and order meatloaf in Manhattan with gravy and beet salad because I know all the moves you'll ever play even those from Fischer-the-dew-hater after he went madder and those who went before and after him and Polger-the-older-sister who comes here and weaves in patterns to confuse the book worms the students who play with their heads not their hearts until they created the machine with emotions that cried its way to victory over the world champion for this is my land my park with no plush armchairs and smoking jackets like my big black friend who plays like a heavyweight boxer with his wrap-around sunglasses and dreadlocks shouting BLOODCLOT UNDER PRESSURE YOU CAN RUN BUT YOU CANNOT EVER HIDE NEXT!!!!!!! not my way to hustle and cajole but gently ensnare a mistake even leave a pawn hanging fruit for the picking a gift for you to lull you into some sense and the flag falls and I shake your hand in this ah yes my park and "Alas, but for the clock. Time is so cruel. Another game, sir, or your friend in the fine hat. I think he saw a move I missed. Is that not true, sir? From the look in your eyes. Yes, on move seventeen? The bishop move. A favorite of Korchnoi's. But you know that from your reading. Another game?"

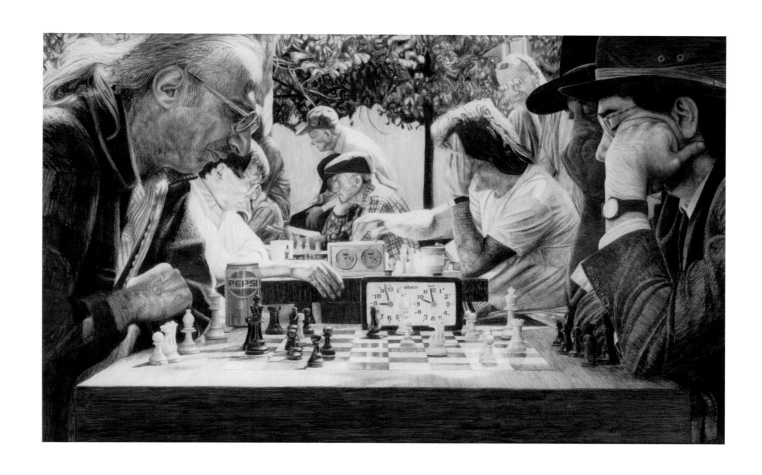

CAVALIER HOTEL

oil on panel, 1984
20 × 16 inches / 50 × 40 cm

Here's the deal Jay's dreamt up for himself. If the next car that comes by has only one occupant then he'll go back upstairs to Donna, wipe the tears from her cheek and say "I'm staying." When she looks up from the pillow he might even say … "forever." But if there's more than one person in the car then he'll take the bus to Grand Central Station, buy a one-way ticket to California and forever never come back.

It's quiet. Just after dawn. Jay watches as a Chinese man rides by on his bike. Of course, that doesn't count.

Janet Lynch drives her fifteen year-old daughter to the Seven-Eleven. The girl, for the third time this week, missed her train and begged her mother to take her to work. They hardly exchange a word along the way. The girl grunts at Janet, then jumps out at the lights on the corner. Janet sighs as the car door slams. She hates driving in the city on her own. No one to check the street names. No one to call out the turns. She takes a left on East 34th Street hoping it'll lead to the expressway.

Upstairs, in the darkened bedroom, Donna lifts the blinds and peers out the window. All she can see are Jay's feet on the step. But at least that means he's still there. Still here. He's wearing his Davy Crockett boots. The ones they bought in San Antonio. He was about to buy the fur hat with the racoon tail, but thought better of it. "You'll never wear that in Brooklyn," Donna had said. So he got the boots instead. The two always crack the Davy Crockett joke whenever he puts them on. It's hot in the bedroom. The fan whirrs a losing battle. When the news comes on the radio the weatherman will say it was the hottest night in five years. Even if it hadn't been so hot, they'd have slept apart, in their double-bed, no skin touching. When, staring up at the ceiling, she reached for his wrist, placed his palm on her belly and said "Do you feel anything?" he moved his hand away and mumbled "No, I don't … I don't feel anything."

The club closes and they all agree that Ron should do the driving. The least smashed. The cleanest licence. And always the luckiest of them all. 'Okay,' he says as Jo, Steve and Seb pile into the back seat and Alec, the biggest and tallest, rides shotgun. 'If we're busted,' says Ron, as he fumbles with the key, 'we share the fine. Agreed?'

'Backstreets …' yells Alec, '… turn right on 34th.'

Donna puts her hand to her middle. There's a pain and a movement deep inside her belly, doubling her up. She rests her forehead on the cool glass of the window. She looks down at Jay's Davy Crockett boots. It's then she hears the screeching of brakes as a car turns the corner and drives past the house.

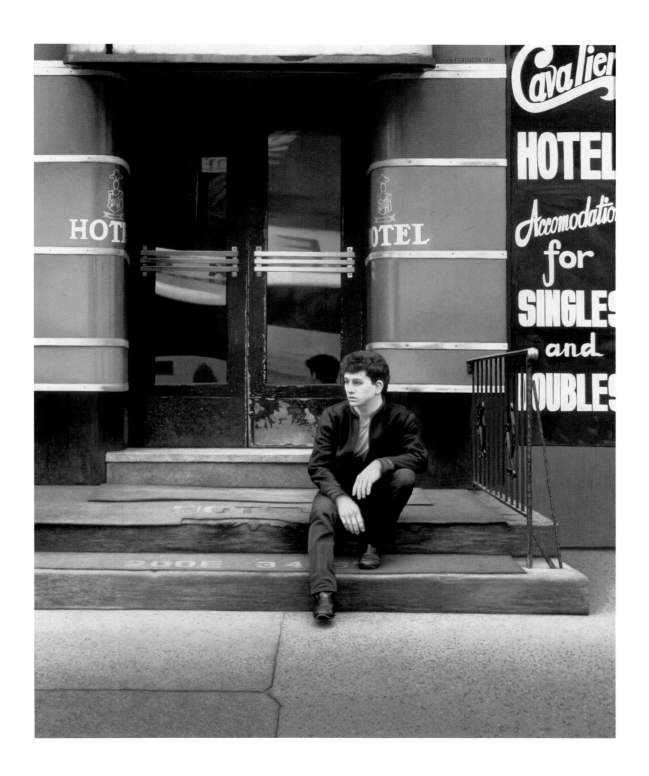

INTERIORS

oil on panel, 2009
30 × 42 inches / 76 × 106 cm

'None of that's important,' she says, 'It's love that matters. That's what we have. We can thrive on love.'

He looks out of the window. Across the park. He sees another version of himself strolling along by the trees. A different man. A younger man. A man more frequently acquainted with the night than the day. One who would walk the city streets as if trying to find something. Something altogether unfathomable. Like the stars. Like the farthest reaches. Waiting in the subway, way past midnight, standing alone on the platform. Next train still to arrive. Some distant rumbling sound. A child's shoe lying on the track: a sandal, scuffed and unbuckled; a page of *The New York Times* fluttering headlining chaos. Shuffling footsteps, then an older man appears from one of the tunnels. Covered in the grit and grime of the streets and alleyways. Hair matted to his shoulders. Gnarled shoeless feet. Talons for toenails. He walks to the edge of the platform. Teeters on the brink. Then he throws back his head. Lank greasy mane for a cape. And he howls. Like a wolf. Like a coyote. Like a man in despair.

She feels the flow of her milk. The pull of the infant boy. Gently, rhythmically, sucking in his new life. She is all but hypnotised by the wonder of it. The nourishment. A gorgeous, hitherto unknowable pleasure. 'We three,' she says, smiling as she mouths the words. '… The three of us.' She thinks of honey. And her father's study, with walls resplendent with exquisite Victorian prints of thistles and heathers, junipers and blood-red roses. The sound of his voice as he spoke to her of stamen and pollen that the ever plump bumblebees carry in tiny sacks on their legs.

In the far distance he sees a flock of birds tracing the sky, receding, then all but disappearing. There's sunshine about this morning. A clear blueness that enervates his being. Something akin to life's longing for itself, for the cycle, the moving forward.

'I love you,' he says, turning from the window, 'and our darling boy.'

Soon enough she curls up on the sofa, and, with the baby safely nuzzled at her breast, falls into a velvety sleep. He takes a cashmere blanket from the bedroom and drapes it over his wife and son, kissing each gently on the cheek. He picks up the vase of lilies from the table, sweeping up the fallen petals in his hand. In the kitchen he places the lilies on the draining-board and empties the vase of its water. Quietly he leaves the apartment and walks the short distance to the flower shop in the market.

On awakening she sees her husband by the window, babe in arms. He is pointing to the sky. 'But the clouds,' he says, '… and the universe is out there waiting for you.' It's then she sees, on the table, in his grandfather's vase, glistening in afternoon sunlight, a shock of violet and yellow irises.

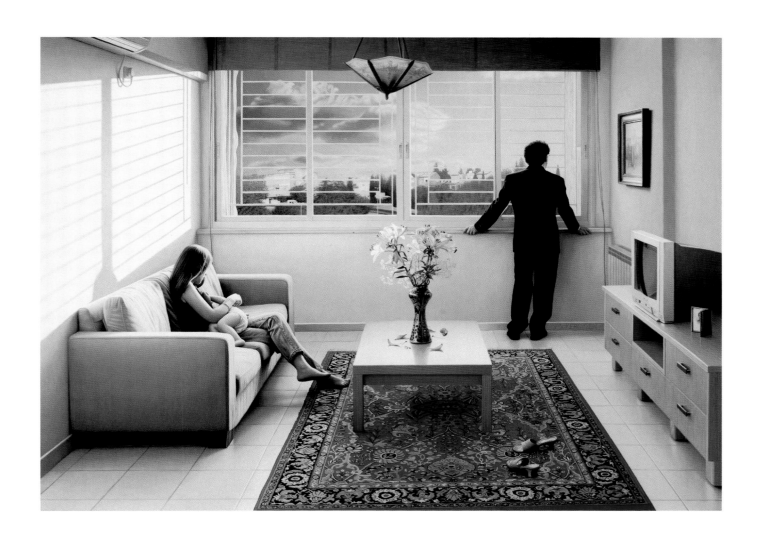

NEWS VENDOR

oil on panel, 1986
32 × 41 inches / 80 × 105 cm

SEDONA ECHO December 9th 1919
–TEARS END BIRTHDAY PARTY–
Robbie Hayes' mother made a chocolate cake for his third birthday party. Little Jimmy Dougan asked Robbie why his dad was dead. Robbie didn't know why, so he punched Jimmy in the face. That night Robbie's mom told him his dad was taken to heaven when he was in France, a long way from Sedona. She told Robbie his father was a hero, that he gave his life so they could be free. She showed him the medal. Robbie wept as deep as any child can weep and said he didn't want to be free. He wanted his dad, not a hero. Not a medal. Robbie's dead father, if he'd a grave to turn in, would have done so, out of sorrow.

———

Tunis TRUTH February 19th 1943
–TENDERNESS AMIDST THE BLOODY ATLAS MOUNTAINS–
Private Robbie Hayes of the 1st Armored Division was wounded at the Battle of Kasserine Pass. His unit came under heavy fire from a battalion of Panzer Grenadiers. Semi-conscious, Private Hayes was found next to the body of an unidentified German soldier. 'I held his hand for two days as he bled to death,' Private Hayes was later to say. 'He was no more than a boy. I put my ear close to his lips while he spoke in a language foreign to me. But I know he was saying something about his mother. I said I would, but knew I couldn't. The sense of guilt will haunt me always.'

SEDONA ECHO February 15th 1973
–NEVER TO COME HOME–
A memorial was held for Sedona's Paddy Hayes. He was a 22 year-old helicopter pilot who saw action in Laos and Vietnam. After a forced landing and capture he spent two years in a notorious prisoner of war camp in the jungle west of Da Nang. Of the 32 PoWs, Hayes was one of twelve who died under the harsh conditions. His father, Robbie Hayes, a World War II veteran, who now lives and works in New York, concluded the eulogy with: 'Somehow this madness must cease. My own father was killed by a German sniper at the Battle of Chesne on the 1st November 1918. Ten days before the end of the war. And now my son. For what? You tell me. For what?'

———

New York VOICE December 10th 1986
–NO MORE NEWS–
Robbie Hayes, 70, has been handing out the news for forty years on the corner of Broadway and 30th. But the developers have moved in, his spot will disappear, and he's decided to call it quits. Asked to sum up his life, he sighs and says 'Too many sad headlines. Not that my story will ever make any.' And the future? 'I might go back to Sedona and write my memoirs. Maybe I'll call them "Read all About it!" Yes. Back home's the way to go. The Native Americans say Sedona's a sacred place. Who knows maybe I'll find some good news there. Some peace.'

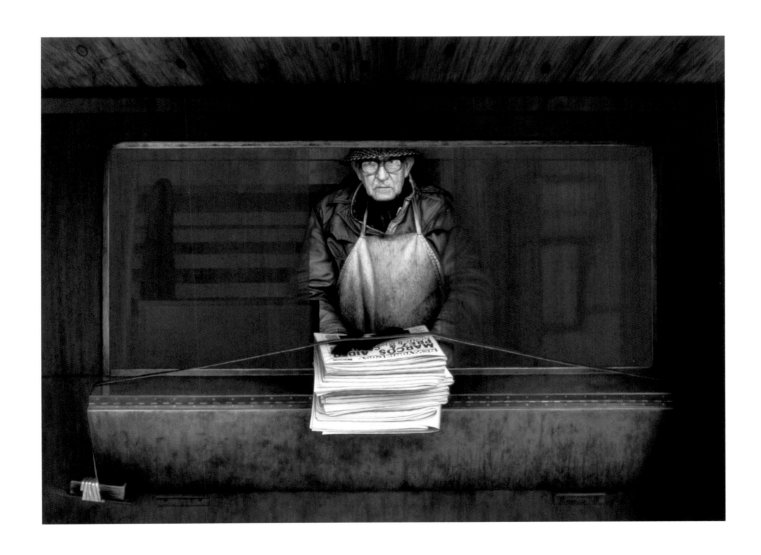

BAR WITH POOL TABLE AND PIANO

watercolor on paper, 2008
9 × 12 inches / 22 × 30 cm

Detective Tom Frost is well acquainted with the night. It's the shift he likes best. When all the citizens are tucked away out of sight. With the streets left to the least, the last and the lost. His people.

He's parked out back of the Tropicana Motel, staking out "Mad Dog" Brougham who's booked into room seventeen with a couple of Philippino girls. Tom's sucking on a quart of Ballantine. Got his flask of coffee and pack of Marlboro ready by his side. Long night ahead.

Then the police radio comes on. There's an incident down at The Troubadour on Montgomerie and Vine. "... a trail of blood in the alleyway ... a stainless-steel machete ... a Winchester rifle and a whole box of shells". It's Martha's place. He squints through the windscreen, weighing up his options, as if there were any. The days of roses may long be gone, but love's never lost. Never forgotten. Even for a hard case like Tom Frost. He flips a bird at the quivering neon of the Tropicana.

His quarry will have a quiet night after all.

'Innocent in your dreams, Mad Dog,' whispers Tom as he turns the ignition key, flicks on the headlights, then steers right towards the freeway.

His car screeches to a halt outside The Troubadour. The scene's already been sealed off. Tom flashes his badge, ducks under the tape and heads through the front door of the club. And there's Martha sitting up at the bar.

'Hi Tom,' she says, as if it had been only yesterday, though it's been so many years. 'I needed a drink, even if it is closing time ... I didn't read this guy.' Tom lights a cigarette. 'The night does some funny things inside a man,' he says, glancing around the room. Trying to get a sense of what he's looking for. The eight-ball's still to be played on the pool-table. The upturned chair atop the piano. No sign of a struggle. No sign of trouble.

'Maybe things'd be better back in Chicago,' says Martha with a wry grin.

Three hours earlier, Mumbles the pianist was practising with Frank, the new trombone player. Frank seemed edgy, nervous. Martha had told Mumbles this new guy had seen action overseas. Not long back. Wild years. She said he deserved a break. Mumbles wondered if Martha was offering Frank something more. Anyways, the set didn't go well. Mumbles told Frank as much. Mumbles said the crowd expected standards. Frank glared skywards.

Martha takes Tom out to the alleyway. There's a photographer with a flash gun. The trail of blood leading to the tire marks shimmers on the cold cold ground.

'I heard you got married,' he says, turning to Martha. She looks at him. That look that says this ain't what we're talking about ... 'Maybe we could meet out for coffee,' says Martha, whose voice tells him there's something special, something unique. 'There's someone ... a young man now ... who I want to introduce you to ... hey, old Tom Frost?'

WOMAN WITH UMBRELLA

graphite on paper, 2003
9 × 11 inches / 22 × 28 cm

A broken child. They said. Me. Then. Standing stock-still on the platform. Forlorn maybe. Left behind. Where the mother? They. Looking this way, that way. Where the anchor? And no umbrella. Then. No umbrella. To protect. From the rainy rain, raining down. And the eaves. The eyes in the eaves. But I'll sing you a song. "Mrs. Magrath, the sergeant said, would you like to make a soldier out of your son Ted? With his a scarlet coat and his big cocked hat, now Mrs. Magrath wouldn't you like that, with a tor-raee-folda-do-da-daa-tor-rae-oor-rae-oor-rae-aa."

The faces in the tunnels, on the stairs, looking through me. At me. Men and women. Moving. A wave. Away from me. Surging forward. Rushing towards their lives. Scared. Their trains about to leave. Fearful. Time-tabled. Anxious. And I, the sole unbusy thing. A broken child I was. Watching the comings and goings. This, my station. Uptown. Downtown. Stop your rushing, your running, your swerving, I'll sing you a song. "As I walked down to Dublin city, after the hour of half-past-eight, who should I see but the Spanish lady, washing her hair in the bright moon light."

Once there was my man, my one true friend. Dragan. The Slav. Those years ago. Always his umbrella. His bottle of red wine. Open and closed. On the bench on the platform. He'd sit. I'd sit. And walk we would. Me singing. Under his umbrella. His ruddy reddy eyes, his blood red wine. And his laugh. His crazy Slav words. And I would sing to him, my Dragan Slav. "Oh daughter, dear daughter, I did not do you wrong, for to go and get you married to one who is so young, for he is only seventeen and you are twenty-one, oh the bonnie boy is young, but he is growing." Dragan the Slav would drink and laugh and keep me safe under his umbrella. In our domain. Our cathedral of light. The pigeons cooing and swooping. Eating the crumbs from our sleeping hands. Outstretched. On our bench.

The midnight train is on time. So fly past me. As if I am not here at all. Not a part of your world. Slow down. Listen. From deep down. My song. From somewhere else. "My young love said to me, my mother won't mind, and my father won't slight you for your lack of kind. And she went away from me and this she did say, it will not be long now till our wedding day."

Then one day. No Dragan. The Slav. At our bench. In our cathedral. Left behind, broken bottles. Empty. And the umbrella. To open and close. To hold the handle. To protect from the eaves. And the eyes in the eaves. High, high above. The umbrella. Winchester '73 ho ho.

Empty now the station. Night time now the station. I'll sing you a song. I the choir. "Umb … er … ella … umber … ella … tra lala lee. Umb … er … ella … umber … ella … that's how I'll always be …"

YANKEE STADIUM

oil on panel, 1992
15 × 23 inches / 38 × 59 cm

'Ben, look, the hot dog guy. It's him.'

'Which hot dog guy? Where?'

'There. Quick before he goes by. See. It's him. Quick, Ben. Turn now.'

It was never proved. Though these days the media will have you strapped and sizzling in the electric chair or on Rikers Island before you've paid your first lawyer's bill. Just look at Michael Jackson? OJ? Oscar Pistorius? You might get away with I never had sex with that woman, or these gloves could never fit this guy's hands, but what do people remember? What do they all talk about? It's daytime TV and all those tabloid headlines that sail one gust of breeze this side of the yacht. There's no need for wood to be crucified these days.

So when (let's call him Hot Dog Seller number 59, to preserve his anonymity, even though you all know who I'm talking about) … so when HDS59 (for short) was pool-side the evening the starlet drowned the media had a field-day. You would need to have been living on Mars then not to have seen or heard all the accusations. Her mother on chat shows telling tales of late night phone calls and black eyes. Tearfully lamenting a life of such sparkling promise so tragically cut short. Then there were his kiss and tell girlfriends coming out of the woodwork. Followed by the trial and the circumstantial evidence from her Facebook account and the text messages he'd sent her the day before. There's a lesson there. But we all know that. Easy to be wise after the event.

All his money got sucked into legal fees to finance the appeal. Inevitably, he was replaced on the sequel. The studio told him to focus on clearing his name. Best all round. We'll get back to you. The stand-in, the young dreamboat from Tucson Arizona, was a smash hit. So, naturally, he was signed up for the prequel. And the sequel to the prequel. The films grossed in the hundreds of millions. So HDS59's phone stayed silent. Then there was the drama of the officer who'd tampered with the evidence. The acquittal, followed by the drug use confessional. The bankruptcy. The inevitable rehabs. The crazy new counsellor-turned-girlfriend-turned-rabbitboiler. Then the infamous fight on the set of series four of "I'm a D-Lister Celebrity Get Me the Hell out of Here." Not a good look slapping the show's host. Even worse that she was a woman. Most unfortunate that she looked uncannily like the drowned starlet.

'You're right, Stevie. You are! It's him. Wasn't he in Star Wars?'

'No, he was in the other one. You know. The galaxy one. With that tree thing.'

'Oh yes and the racoon.'

'No not that one. No it wasn't the racoon one.'

'Who cares?'

'Yeah, who cares?'

'But it was him. The one who did it. Killed that girl.'

'He strangled her. Dumped her in the lake.'

'Shall we call him back for a hot dog?'

'No. Too late.'

'Next time.'

'Yeah … maybe.'

SELF-PORTRAIT AT JULIAN'S

oil on panel, 1994
30 × 20 inches / 76 × 50 cm

Close on midnight. Snow falling gently. Looking through the window of our bagel shop. It may be twelve years on, but it all seems so familiar. Except for the young boy behind the counter. On the late shift. Inside, joining the short line, the smells, the tastes, come back to me. On the wall, the black and white pictures: my grandfather and father in the doorway, the new sign etched into the window; then myself and my father at the ovens in the bakery. How old was I then? Fourteen, fifteen?

'Salmon, cream cheese and chives,' I say to the boy, who has no idea who I am, where I come from, where I've been.

It's Thursday night, so I know where my father will be, even though we've had no contact this decade and more. He never once replied to my letters and postcards. Not even when the Yankees won the World Series. Nor the time I sent him my first book of poetry. From the Blue Tiger Press, Gilroy, California. The garlic capital of the world. A poet picking garlic. Almost Latin; almost South American. The poems. My poems. What it means to be a man. To be a son. Prodigal or otherwise. Returning or not.

Like the bagel shop, nothing much changes at Julian's. The electric hand dryer, maybe. But the red and black tiles on the floor. The clock that has hung high since the doors opened. Walking up the stairs, (the ascent to manhood, the rite of passage that first time my father ever took me through the hallowed entrance). Walking up the stairs I hear the sound of the pool balls clunking together on the baize. The sweet smell of Lucky Strike. The glare of the fluorescent lights.

Pausing at the top of the stairwell, leaning on the handrail. Unsure as to whether to go or stay. And there he is on his favorite table. Focussed. Bent forward. A tricky shot on the eight-ball off the far cushion. I stand still. In the background. Fearful, wary of disturbing his concentration. Of interrupting the flow. His cue action is measured and assured. The black ball meanders towards the cushion, all but hesitates, then falls into the centre of the pocket without touching the sides. I watch him as he straightens himself, smiling and nodding to Marty. Marty walks around the table and the two old friends slap each other on the back. There's something in their ease, something in their complicity, that creates in me an emptiness and yearning. Then he turns. He sees me. There is no telling in his expression. Not of love. Not of indifference. Not of the pride in his son that I desire most of all. He looks at me across the room. That same look from that long ago day, when, standing in the bakery, I dared, I chanced, to tell him of my dreams. I want to walk across this space. I so much want him to know.

MY FATHER AT MOUNT SINAI

oil on canvas, 2011
36 × 52 inches / 91 × 142 cm

Looking into each other's eyes. Holding dear these precious moments. A reversal of sorts, in the turn of events. A name-band to tag in case of forgetfulness. If words fail. If all gets lost. And will you take away with you his watch? When the time finally comes? Your father's watch? Will you slip it on to your wrist? When the time finally comes? His watch. That matched his pulse. The rise and the fall of the day. Marking off the seconds. The breaths. The heartbeats. That observed the ebbs and flows from child to youth to man. Checked the minutes needed to meet the train. The walk from here to there. Well timed. Even rehearsed. Those some-time hours passed in anxious wait. For an event. A joy. A calamity. All the small and large events. Of a life well lived. That looked and said it's time to go! the game's about to begin! ten minutes 'til bed time! let's not be late! we're early! The metronome of decades, now melding into moments. Now telescoping. The house of prayer, where you stand, where you lie down. How the hands turn back and pause, returning time to the source. In a forest. A first flush of love lain out on a picnic rug. Of wool. Of taffeta. Ruffled on the dank-leaved grassy slope. The sound of water. The sense of promise. A moment to cherish. Another moment. A game of pool under a fluorescent light. Like a winter's night. Snow in the darkened street below. The smooth special table. Like a lawn. Blue or green. The spheres, solid and weighty. A field of dreams. You two. Like communion. Like complicity.

The watch. Ever present. Pacing the future. Leaving the past in its wake. The watchman, just out of view. Awaiting the allotted hour and minute and second. Patient. No soothsayer is he. More an angel. More a ferryman. The punt, still on the pond. The far shore in view. The long-stemmed oar gripped lightly. Held lightly. And, you must, when the time finally comes, with your slender fingers, gently wrest the watch from your father's wrist. A passing away. A passing on. Taking on the mantle. Taking over the baton.

When the time comes. Reverently, lovingly, you push apart the silver links of the strap; pass it over your fingers, your thumb, the meat of your hand, until it comes to rest, to home, on your own wrist. You look at it. The glass face. The simple dial. The numbers. Counting out the allotted time. Of seconds. Of days. Of years. And you observe the sinews of your arm. The back of your hand. The fingers. And you see what you've known all your life. All along. You stretch the muscles, the ligaments, feel the strap expand. You relax. The strap contracts. Settles. In the quiet you hear the tiny sound of time moving forward. In time honoured fashion. All fathers. All sons. The natural order. You this way. He that.

KATZ'S V

oil on panel, 2010
20 × 20 inches / 50 × 50 cm

This strange tongue. Only yesterday Carlos was told that 'rain', the stuff now tumbling out of the sky over the Bronx, can mean three things. One to do with a horse, one with a king, and only one, the one he thought he knew about, was that which falls gently on his beloved Bogota, sweeping down from the clouds of the Andes. All this from his self-proclaimed mentor, Azizbek, a crazy guy from Bishkek who'd arrived in New York only three months before Carlos. Azizbek was already a short-order chef and could flirt with the waitresses and swear in American.

'In Kyrgyzstan, we eat fat. That's it. That's all we eat,' he said last night, as they sat in the alleyway with the bins and the tom cats. 'Fat … you understand me Carlos, you dumbfuck Colombian?' said Azizbek, squeezing the huge roll of flesh hanging over his belt. 'Yum, yum …' he said, pretending to eat himself. 'We have a café in Bishkek where only on the menu is fat. Fat noodles, fat soup, fat meat.' Then they both looked longingly down the length of the alleyway, forever foreign: the smells and sounds of this city. The tastes in the night air. Carlos smoked his cigarette, happy to have this friend, even if he barely understood a thing spewed from his mouth.

As he mops the floor, the tables cleared, the chairs stacked high, the day's work nearly at an end, Carlos thinks of the words he will write on the postcard to his mother and father. He imagines them in their tiny shack in the barrio on the hillside of Bogota, close to the ravine where the cartels dump the burnt bodies of those who dare to cross them. Azizbek said he will help, but Carlos wants these to be his words. From his heart. So that they will be proud of their son who has made his way in the world. Away from the guns and drugs, the bombs and the calls in the night that have to be heeded. He chose a postcard of the Empire State building. Something about it rising to the clouds, reaching for the sky.

He forms some words in his mind as he mops. 'Once the tallest building', he remembers from what he saw in a brochure. 'The New York Times is my daily', recalling the advertisement from the newspaper left behind at table thirteen. But he knows the word 'love'. He knows 'mama and papa'. And he will write 'it is raining'. Azizbek appears from the kitchen. 'You want help with your postcard?' he shouts from across the counter. 'Tell them the streets are paved with gold … and the girls are easy over … sunny-side up.'

He laughs hysterically. Carlos smiles, the crooked smile of the ignorant.

'Eat fat, dumbfuck,' he shouts back, blissfully unaware that he's made his first joke, the first of many, in this new land of his. This land of three reins.

WOMAN IN COFFEE SHOP

oil on panel, 1982
16 × 20 inches / 40 × 50 cm

Leah Jackson shifts on the stool and leans on the table. There's a tightness in her chest that has only something to do with her having taken up smoking again. Camel untipped. Leah thinks her mother thinks she has a daughter who no longer loves her. Who never considers others. Who most of all never now thinks of her mother's needs. Leah thinks her mother thinks she has a daughter who she can still hold hostage, love or no love.

Leah's mother has just called to say that the cab was late and got stuck in traffic on Fifth Avenue. 'Don't be cross with me,' she whimpered, in that way Leah thinks she always whimpers when she's telling a half-truth. 'You know I love you too much for you to be cross. Be with you soon, sweetie.'

Leah thinks that once her mother walks into the cafe she should say what has to be said, then stand and leave her (her one and only parent, who expects too much, who would let her daughter grow old and worn, suffocating in a life she'd never come to call her own). Leah thinks her mother thinks her daughter should pay back all the years of martyrdom and love. Leah thinks this is a moment she cannot shrink away from. Ever since her mother agreed to meet, on neutral ground, away from the family home. Some place where they could talk.

Frieda Jackson sits in the back of the cab as it makes its way through the early evening traffic. Frieda opens her handbag and takes out the small silver compact she still treasures from the old days. Frieda Jackson thinks her daughter thinks she has a mother who never listens to her. A mother who speaks too much. Who never lets the silence settle. Frieda thinks she should stand firm, make eye contact with her daughter (her one and only, the love of her life, the girl she sacrificed all of herself for, singularly, without complaint, without hope or expectation of support). Frieda thinks her daughter thinks her mother is purposefully late because she doesn't want to hear what might be said. Frieda thinks this a moment she has been expecting. Ever since her daughter said she wanted, needed, to talk.

Leah sees the cab pull up outside. Her mother stepping slowly onto the sidewalk. She thinks she should look away, to hold off the moment. The café door opens and there stands Frieda Jackson. Leah thinks it's time to hold her mother's glance, to look into those eyes that have somehow turned so sad, as if fearing a future to be faced.

Leah leans forward. A gesture. The heat of the cigarette stub tingling the skin between her fingers. A warning. Frieda takes one step towards her daughter, then stops. As if this may be the last.

There is a space between them, once unimaginable. Like a chasm. All the air in the room. Their eyes meet. 'Mother …' says Leah.

COLONY HOTEL

oil on panel, 1999
29 × 29 inches / 74 × 74 cm

'Naomi, just remember how you were … at Rachel's age.' — 'What do you mean, Benny?' — 'Well … how much did you think … well, more like need to be near your parents? Back then. When you were young like Rachel? Once we got married.' — 'But there's near and there's near. Italy's far. No way does near come in to it. For me Jersey was far. Atlantic City was far.' — 'These days nowhere is far. Hop, skip,'

Slowly, Benny turns his face to the Delray Beach sunshine.

'But Benny, why Italy? … why couldn't he just stay here? Like all the other Italians.'

'Most of the Italians are in Italy.' — 'Not the New York Italians.'

'You know … he told us … the family business. He wants to feel the soil. And he wants our Rachel … our daughter … she's his wife now … to be there with him.'

She looks at him. They both know the subtext.

'It's the Catholic in him, Naomi.' — 'Don't go there, Benny.'

'Where?' — 'Please, don't joke with me, Benny.'

'Okay … but you worry too much.' — 'It's a mother's duty to worry.'

They fall silent. The sky is a blue you could pour into a glass. They watch a bird carve an arc above their heads. The morning sun is warming up nicely.

'So,' says Benny. 'There's a son and he's worried about his father. The way he's behaving. So he takes him to the doctor. The son waits awhile. Then his father comes out from the consulting room. He looks alarmed. Sits down next to his son. "The doctor says I've got Alzheimer's." There's a long pause. The father looks confused, distant. Then he jumps up from the chair … "At least I haven't got Alzheimer's".'

She laughs. Not just at the joke, but because her husband, this Benny of hers, has always been able to make her laugh, make her smile.

'We could move down here.' he says. 'How many more New York winters do you want? Florida. Where everyone is old and everyone is beautiful.'

'Don't ask me that. Not now. Not with Rachel.'

Way up high an aeroplane heads out across the ocean.

'What shall we do today Benny?' — 'How about the movies?' he says, excited as a teenager. 'In the morning!' — 'The morning?' — 'Why not. The sun'll be here all day.'

'Like when we were young, eh Benfny?' — 'Like the first time we ever kissed.'

'In that flea pit picture-house in Brooklyn.' — 'The "La Dolce Vita" up on the screen. Remember?'

'How could I forget … all those subtitles.'

'They make great movies!' he says, 'Italy smitaly, eh Naomi … Here's to the Florida sun. And orange juice. Maybe there'll be a "Midnight Cowboy" matinee. Good Jewish boy in the lead!'

She smiles at this husband of hers. Infuriating in his refusal to see anything but the best in life. She smiles at her good luck. She smiles at her happiness and the never to be forgotten kiss in that cinema in Brooklyn, with the romance of Italian as a soundtrack and love in the growing.

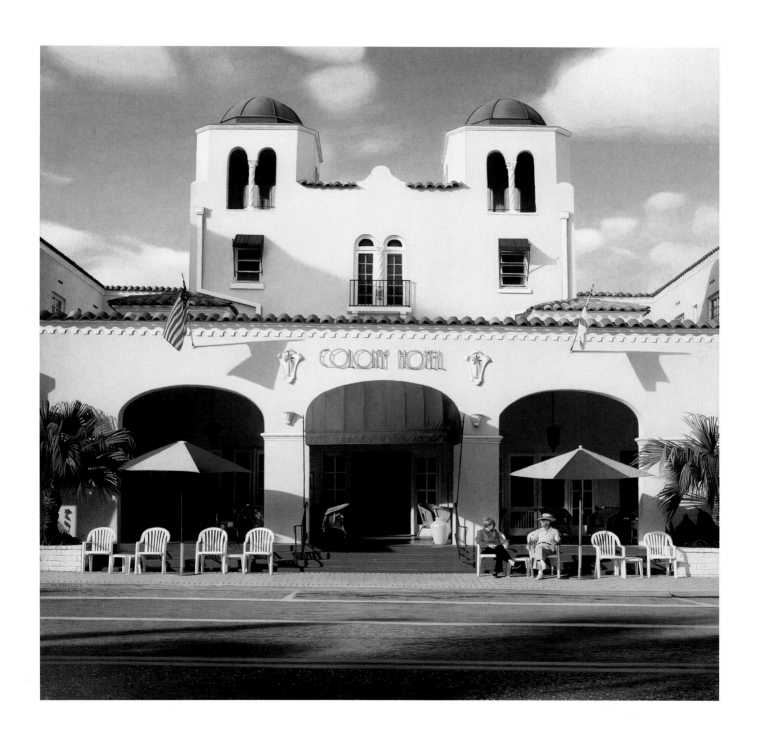

HIS FATHER'S GLASSES

oil on panel, 2016
12 × 18 inches / 30 × 45 cm

Reuben's father is special, as all sons' fathers are.

Jacob is his name and Reuben finds much in him to love. Not that he'll always say as much. What son does? (Though, of course, they should. We all should). But if he did. If you were to quiz him. This late afternoon as he sits alone at the table. Alone, but not lonely, mind you. (No one is alone in this house). If he was of a mind to give an example of his love, this would be one.

Reuben loves the way his father jumps up during dinner, saying "wait while I get my glasses." Jacob looks on the sideboard, the mantelpiece (mumbling "where are they?"). Then he finds them (invariably close by), rummages through the pages of his evening newspaper, sits back down and says "Now listen to this!" He reads out loud with such enthusiasm, such zeal, that his family is captivated. An outrageous headline. An outlandish scandal. All edifying. All instructive. All entertaining to his smiling wife and enraptured children.

If you were to press him further. This Reuben, son of Jacob, as he plays with his reflection on the varnish of the table. If you were to say, tell me more. In this moment, with his father's spectacles in his hand, he might put it another way.

He loves the strangeness of his father. His delicious peculiarity. The way he sometimes looks at you while he's reading a book. Like the Tanakh. Putting the book down, taking off his glasses, chewing on the end of one of the arms, saying, out of the blue (like he did one wet school-holiday Tuesday) "You be Abraham and I'll be Isaac. Get a knife from the kitchen and we'll see how we go ... and some string ... and the dog as a ram ... and a pot plant and some matches." The playfulness of him. That's what Reuben might say. On reflection. On another day. Later on in life. Learning from Jacob, teaching, through play. Through fun. In presenting life through his own special prism, Jacob's own unique and beguiling way of seeing. "If you could see the world through my eyes," he sometimes says, and Reuben so wants to do so.

Let me tell you something. Reuben, son of Jacob. In time your sight too will blur and you will need glasses of your own. For reading and otherwise. But your vision will sharpen. And you will see with clarity.

But for now. Be a child. This precious time of father and son. Son and father. In a few minutes, as you sit at the table, you'll hear the car pull up in the drive. Footsteps on the pathway. The key turn in the front door. Your father's voice. "Sara. I'm home. Would you believe it? I left my glasses behind ... somewhere." And you will jump from your chair and shout out, almost in laughter, surely in happiness. "Dad ... they're here. On the table. Your glasses. I have them."

GIRL IN MIAMI

oil on panel, 1999
20 × 30 inches / 50 × 76 cm

'Hey pretty girl. Look at me.' So says Joe. This beautiful young girl framed by the ocean, the blue sky, the shimmering beach. 'If the boss says there's no job, I'll find you a job. Eh, Brad,' he says, turning to his friend who's back inside the kiosk, cleaning down the surfaces.

'We can find plenty of work for pretty girls like you. Thursday, that's your name, yeah? Even though today's Tuesday. Thursday all week. Every day.'

Joe pauses, leans forward, stares at the side of the girl's face. This girl who stands there, looking away.

'Don't like me already?' he continues. 'They say I look like Al Pacino ... You wanna be an actress, don't you? The boss showed us your resume ... another wanna-be from film school. I can act ... Look ... "You talkin' to me?" ... or was it the other guy ... Robert de Niro?'

Down the beach Thursday sees an old woman walking a dog. It's sunny and she wears a floppy hat. She's tall, dressed in a pastel green jacket and matching skirt. And white shoes with a pointed heel that might look out of place on a beach, but the woman has panache. A presence. Her dog is a full-sized poodle. Black with a pink collar and a white bow tied in the hair between its droopy ears. The dog's diamante-studded leash sparkles in the morning sun. As the woman approaches she seems to grow more elegant, more assured, more spectacular. Even without seeing her eyes, shaded by silver-rimmed sunglasses, Thursday senses an aura of greatness around this old woman

with a dog that glides by her side. A star from the golden days of the studios? A leading lady. Kissed and feted. Adored and adorned. The old lady stops. No more than twenty feet from where Thursday stands. Majestically, almost in slow motion, her dog sits by her side, without the hint of a command. She brings her gloved hand to her forehead, a salute almost, to shield her already shielded eyes from the low-lying sun. Thursday follows the old lady's line of vision. There on the horizon of the Atlantic Ocean is a fifty-foot yacht, fulsomely sailed, racing with the wind. The old lady, the diva, the goddess, watches it progress. What memories, wonders Thursday? Of Cannes? Monte Carlo? The Isle of Capri?

'Hey, wanna-be-actress-girl,' says Joe, breaking the magic. 'Just called the boss. He's not coming in today. Or tomorrow. Tell her come back Thursday, he said ... hey, that'd be good luck. Thursday's child is full of grace ... hey ... maybe you can be Grace Kelly, the one who died in the car crash. Just like that Mansfield chick, but with her head still attached ...'

Thursday carries on ignoring this Joe from the kiosk. She hears some more of the words ... "beauty queen" ... "pumping gas" ... "Miami vice" ... but she is entranced, beguiled, by this elegant lady who looks out to sea. And the marvellous white-sailed yacht, licking the wind, forging its course through the crystal clear waters.

HARLEM NOCTURNE

oil on panel, 1985
24 × 17 inches / 61 × 43 cm

I like to sit I do I do. Atop-the-top-top-building. I like to see the night time view atop-the-top-top-building. When no one knows that I am here, when no one else is peeping near. I like to sit I do I do, the city spread like backaloo.

To see the cars go snaking by atop-the-top-top-building. To hear the voices break the night, amidst the quiet, the broken fight, the city growls, city zoo, the city spread like backaloo.

What the see? What the me? What the spindly-spangled tree? The city spread like backalee.

Superman flexed in force and in flight. The city spread like backalight.

Spiderman me. Climbey man me. The city spread like backalee.

Out through the window. Daring to edge, pigeon steps along the ledge. The thought, the tumble, the cityscape rumble.

Do look down. Do look down. Do look down at the tumbledown town.

Dark up here, the wind, the rain, the sights and sounds, the sound and fury, the city spread like backalury.

My special place, my eyes, my face. On rooftop and tile. The city spread like backalile.

In thought and in spite, a prince of darkness. The city spread like backanarkness.
And so …

Do you see the world I do? On this my Harlem night? In this New York City zoo? You, the crooked pilgrim kora walking? You, the troubled crazy-man talking?

You, the babe at mother's milk, wrapped in swaddling lined with silk? You, the Shona climbing hills, reaching clawing monkey skills? You, the student gallery gazing, Vermeer, Turner, colors blazing? Do you see the same world as me? The crowd, the street, the night, the trees? Does she, does he, the madman screaming, the baby in the cradle dreaming? Is all the same, the same for all? The words we form … the words I scrawl?
And now …

Tread softly this Harlem night. The city spread like backalight.

I like to sit I do I do. The city spread like backaloo.

I like to sit I do I do. Atop-the-top-top-building. I like to see the night time view atop-the-top-top-building. When no one knows that I am here, when no one else is peeping near. I like to sit I do I do, the city spread like backaloo. To see the cars go snaking by atop-the-top-top-building. To hear the voices break the night, amidst the quiet, the broken fight, the city growls, city zoo, the city spread like backaloo.

Hold back the night. This Harlem night. This city pity barnum fright. Nocturne. Knock. Turn. Pigeons in the rafter. Happy ever after. Windows open with Cole Porter tunes. Guns that pop and slaughter looms. Sounds and blood and fury. Hold back this night. This Harlem nocturne night.

I like to sit I do I do. The city spread like backaloo.

To see the cars go snaking by atop-the-top-top-building. To hear the voices break the night. This Harlem night, this broken fight. This nocturne height. The city growls, city zoo, the city spread like backaloo.

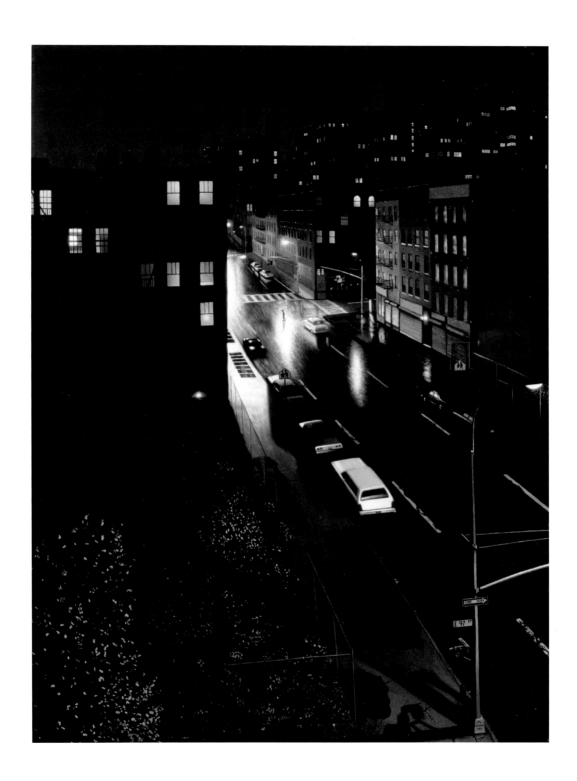

MATINEE

watercolor on paper, 2015
12 × 18 inches / 30 × 46 cm

Ever since he was a boy. From the time his father first took him to see the "Bicycle Thieves", with the afternoon sun flooding the streets outside. The deliciousness of it. The wickedness of it. As if stealing away himself. Hiding and snuggling away from the world. With ice-cream so closely following on from breakfast. He peered up at that screen, in awe, in bliss. His father by his side. In sublime collusion.

And that final scene. That first time, before the heavy crimson velvet curtains signalled an end. The father had to take the bicycle, he had no choice. And his poor son. Bereft, alone. The crowd surging past him, baying for blood. How he felt for that boy. How he had to be comforted. Outside. In the glaring, the unreal, sunshine. The street bustling about its business. Unaware of the drama, the inequity. His father held his hand. Knowing it was so much more than a film.

Ah, that boy on the sidewalk, crying for loss, would come to such sights colder, by and by. His father would pass away, as suddenly, as abruptly, as that bicycle thief was swept from the streets of Rome. His world would shift and crumble, as worlds sometimes do. He would grow up in a house of adults who never told the truth, where the click of rosary beads echoed through the hallways. But the matinee. There would be his solace. There he would find comfort. While friends played football in the street, kissed girls in cobbled alleyways, he would settle into the cushioned seat of the old cinema. As the lights went down, as the sound of the curtains opening somehow defied the laws of physics. And then he would breathe a sigh of contentment. A sense of ease wafting over him. The dark enveloping, entrancing, holding him in the moment. And what films. What delights. Happily alone. Gladly alone. While outside, the tumbling and cajoling. This hidey hole. This priest hole.

The teenager grows to be a man. The house of lies is left behind. He gets a job teaching the violin to children with little aptitude. He lives in a single room above a bakery. The smell of fresh bread his early morning lover's kiss. He eats his meals in the bistro down near the river. Always alone. But not lonely. Not a man of discontent. Not peculiar. Long since accepted by his fellows. This music teacher who is kind to his pupils. Who is patient.

The allure of the matinee never diminishes. Sometimes. On a very hot summer's day. Or on a special festival occasion. He will be alone in the cinema. Just he. Then, just for a moment, as the lights fade and before the curtains open on to a new world, he returns to that first time. That moment. His father. Next to him. Close. Strong. And the man who had to steal a bicycle. And a small boy who had to face the world alone.

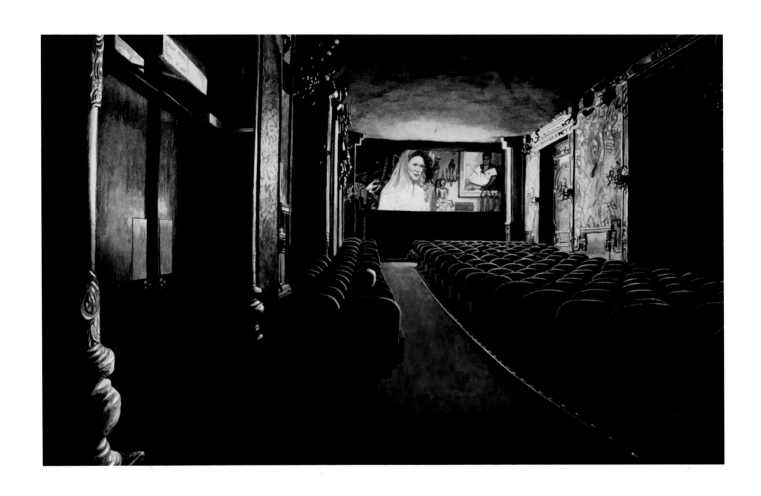

WOMAN IN BATH

oil on panel, 2009
11 × 8 inches / 28 × 20 cm

Violet knew this fear was irrational. Most fears are. But this one was plain stupid. Or so she'd tried to convince herself. Up until yesterday. Now, in her apartment. Soaking in the bath. Alone. Perhaps the fear was real. Rational. Far from stupid.

It was the picture in the art gallery that started it off. She was five years old. Her parents loved taking her to exhibitions. They'd always play the same game. Each would pick a favorite painting and the others had to guess which one it was. On this particular day Violet ran into the allotted room ahead of her parents, eager to make her choice. She moved quickly from picture to picture, discounting one, reserving another. Then she stopped in front of a large canvas and gasped. It was like nothing she'd seen before. Its peculiarity. Its murderous shadow. When her father arrived his daughter was catatonic, riveted to the spot. He swooped her up in his arms and deposited her in front of a riotous Kandinsky. Munch's violent image still swirling in her mind. Marat dead in the bathtub. His naked assassin. All mixed up with the kaleidoscope of color now before her. Dizzying. Unsettling.

From that visit on she battled against lying in the bath. Her mother tried soft music from the radio, candles, bubbles. She'd even sit on the edge of the tub, singing lullabies to her daughter. But it made little difference. Her parents relented and bought a shower attachment for Violet to use. When Violet grew up and became a teacher she always chose apartments with showers. A harmless indulgence to eccentricity was her reasoning.

Five years ago she got her dream job. Head of a centre for violent adolescents. The apartment came with the position, and the bath came with the apartment. She resolved to make no fuss. See it as an opportunity to put to rest a childish nonsense. Yet, more often than she'd like to admit, as she eased herself into the body of water, she'd be captured by a feeling of unease, a bloodied image returning. Then, yesterday evening, she spotted Elroy in the supermarket. Glaring at her across the aisles. She'd last seen him four years ago in her office. He'd long been deemed a hopeless case, with a history of rage and manic violence in the classroom. No regular school would accept him. The worst of the worst. Violet had put so much effort into Elroy. She'd sat with him for hours on end. Once, even held him close. But she had no choice. The evidence was clear. It was he who was pimping the girls. He who'd beaten Mary O'Neil to within an inch of death. Yet, Violet felt compelled to visit him in juvenile detention. To admit that it was she who'd called the police. His eyes had dulled. He'd whispered words that only she would hear. Of revenge and butcher's knives. Of hunting down and brutality beyond her imagining. Beyond her darkest fears.

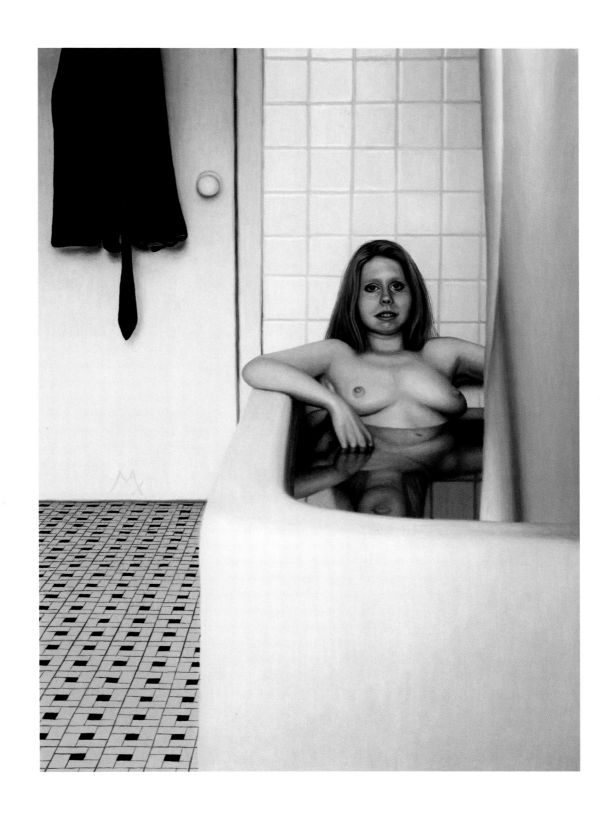

TEA

watercolor on paper, 2000
6 × 10 inches / 15 × 26 cm

Siobhan stifles the tears. In a few minutes the waiter will return with the toasted sandwich and coffee that her husband ordered (before he stormed out of the room), and she doesn't want to elicit concern or sympathy. Most of all she doesn't want to be crying in front of her daughter. She needs to be strong. Now and forever. From this moment on. From that very second her husband slammed the door, leaving her bereft. Finally. Mother and daughter alone.

The fire in the hearth is hot on her back. Siobhan cannot see, but knows there is no one else in the room. No one has come and there's no one to leave. She hears and feels the crackle and pop of the fire. And the emptiness. And the height and weight of the room. The mirrors and the pictures before which she has stood and stared. In those glorious days, pacing the floor in quiet anticipation of a stolen afternoon with her husband-to-be. To drink tea and talk of books and the life they will carve together. The beautiful baby child she then held in her belly. Erin, if a girl; Liam, for a boy. This place of tea and scones, hot chocolate and buttered toast. She knows this room so well. The pastel pinks and greens of the wallpaper. Has traced her fingers along the patterned lines, felt where the strips of paper have been joined (matched almost to a tee).

She remembers a line from a novel they both loved by John Berger. "When they're lost all loves haunt us in the same way". Now her shrivelling heart tells her there's truth in storytelling.

She thinks she should look up. To marvel at the sea-blue eyes of her one and only child. Those eyes of her man and of a passion long-time past. To look up. To face the uncertainty of a future that was once so assured. To find the words. To tell her child that which no child should ever have to hear.

Eight year-old Erin looks over her mother's shoulder. In the reflection of the huge mirror on the far wall she sees the chandelier. Glancing upwards and there it is, hanging gloriously heavy, flecks of flame caught and glittering in the sparkling glass. She is mesmerized by the pull of the beaded crystal, the magical fire caught in a prism. As wild and elemental as the mane of red hair cascading down her back. She wonders did her father get so excited, standing up so abruptly, running almost to the door, because of what she'd said in the street? Was it the feathered cap she'd seen in the shop window that he'd rushed off to get? The one she'd pointed to, whispering her longing in his ear?

From the corridor, behind the closed door, comes the sound of footsteps. Siobhan feels her pulse quicken. Erin raises herself from where she squats on the chair. Both hold their breath. In anticipation. In hope.

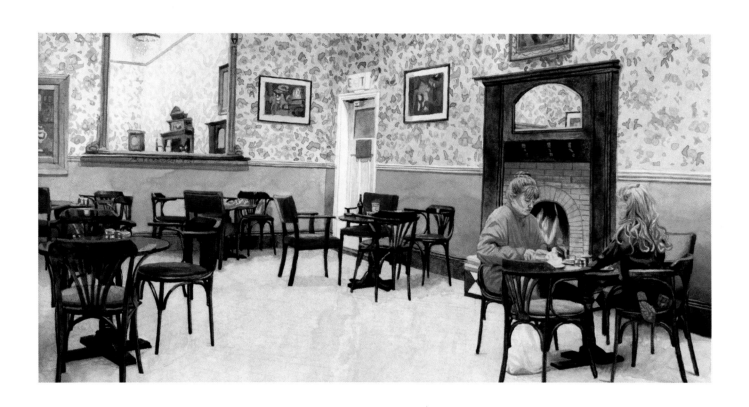

MY FATHER IN THE SUBWAY III

oil on panel, 1984
22 × 28 inches / 57 × 72 cm

He has a kind face. I will ask this man. One that surely has seen and shared its own world of troubles. I will ask him. He with Moses' breath in his lungs. Who once, I do not doubt, in a time gone by, was not of this city of dreams. The face and form of his ancestors. This outcrop of nature. This clay grown tall. I'll ask him. Yes, him. He has kind eyes. Of an age and demeanour unafraid of a stranger's approach. A stranger's plea.

On another day. If the world had turned out otherwise. With a different set of causes and conditions. Then I might have told him something more of myself. Maybe the story of how I rescued the lamb that had got trapped in the thicket. When I was a young boy. Far from here. How I'd pulled it from the thorny bushes. Held it close to my chest, though I was barely much bigger than itself. Then took it back into the field to its mother. Or how I used to walk along the dusty track with my grandmother. Holding the small pitcher of water to give as alms to the wandering monk. My grandmother, poor as she was, with two balls of sticky rice wrapped in palm leaves in her bag. We two, waiting on the road side for him to pass by. The ancient monk shrouded in his vows of silence. Day after day we'd go. One day after the next.

These are things I would tell you, might tell you.

If we're to become friends. If we already were.

Now not these things. But of Mr. Leitz the landlord. He who presses us for more money. Who threatens us with authorities I know nothing of, but fill me with fear. And my wife who is terrified to go outside our tiny rooms. Not knowing what is said in the streets. What is shouted. What is not. Wherein lie the threats in this ramshackle alien city of cars and mountainous buildings. Keeping our children close by her side for fear of all that is unknown. While I work two and three jobs to satisfy the demands of Mr. Leitz the landlord. Can he do to us what he says he can? You have a gentle face. A wise presence. Of this and other worlds. You can see we are connected. By the simplicity of blood. Of flesh. Of our elemental nature. You, like me, will know that if we were to die. Here. Now. Together. Fall to the ground together. Then we would merge. Dust into each other's dust. Melting back to earth.

I feel the surge of wind. Presaging the train. And with its arrival your sudden departure. Robbing me of my one chance. To connect. With someone my heart tells me will help. Will show sympathy. Empathy. So now. I must step forward. Be brave, for bravery is needed.

'Sir ... Please help me ... Tell me what I can do.'

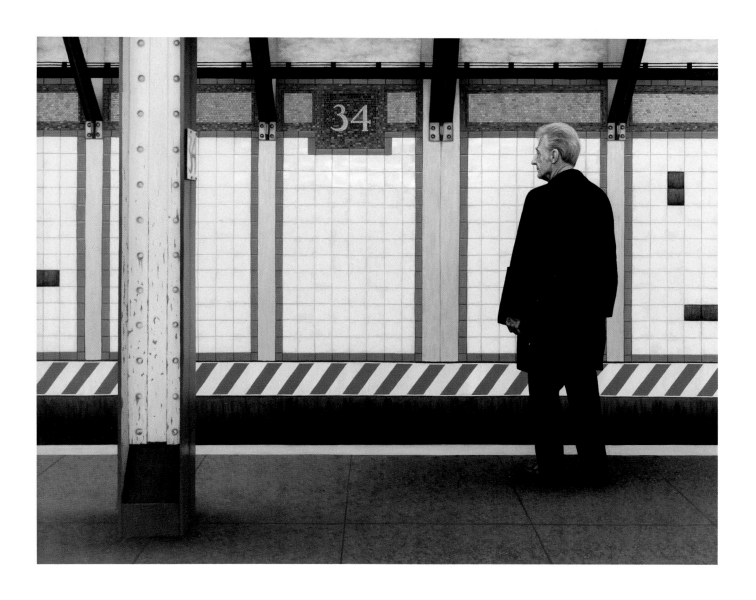

WOMAN BRUSHING HER HAIR III

oil on panel, 2001
8 × 10 inches / 20 × 25 cm

When she was in grade school, the mean kids would call her 'beaky', 'eagle-face'. And, sometimes, in sadder times, when such abusiveness went unpunished, even 'Jewgirl'. Her mother would hold her close, whispering 'take no notice … children can be so unkind' … 'you are beautiful'… your nose is a gift from your grandmother'. Sobbing and gulping, Krystina Kwaterski had wished her grandmother had kept her nose to herself.

In one of those huge sweeps of synchronicity, seventy years earlier, Krystina's grandmother, Vera, had stood before an SS officer on the outskirts of Konigsberg and recited the catechism to prove she was a Catholic and not a Jew. With her baby brother in her arms, the eleven-year-old Vera then fled Konigsberg ahead of the tide of Russian forces sweeping in from the north. Her journey would take her to the Black Forest, on to London as a post-war domestic, and finally to the welcoming sight of the Statue of Liberty and Ellis Island. The only possessions Vera carried with her, an anchor to the past, were her mother's hand-glass and hairbrush. The very same, bequeathed to her darling grand-daughter, which Krystina now holds in her hands on this frosty New York morning.

Barely a day passes, as she goes through the delicious ritual of brushing her luscious hair, without her thinking of her grandmother. The way, for as long as she can remember, that her grandmother would stand behind her, combing Krystina's hair, singing old Prussian folk songs, talking of the forests of silver birch, and the smell of pumpernickel bread baking in the oven.

This morning, ice on the streets, Krystina is aglow with the events of the night before. How the dearly departed Vera would have loved the wickedness, the beauty of the story. Even though Krystina had broken one of the few rules she applied to herself. No one night stands. But he was handsome beyond belief. And Blessed was his name. Last night at Oliver Mtukudzi's first New York tour, downstairs at that new club in the Village, Krystina fell for Blessed Mubvunzo as easy as falling off a log. This Shona warrior, this sculptor of stone, who would, one day, be feted as a master craftsmen of an ancient art and tradition.

As she brushes her hair, reliving the passion, the surprising intimacy of their night together, how can Krystina know the events that will unfold? That Blessed will walk up behind her, kiss her gently on the neck, and whisper 'we will be together until we are old'. How can she know, as her body tingles to the quick, that they will bring to the world a daughter, and call her Precious Mubvunzo-Kwaterski (to ensure no one else on earth can have such a name)? And how can Krystina imagine that one day this daughter, tall and proud, with skin of the gods and a profile of unsurpassed elegance, will brush her thick black wavy hair, lovingly holding in her hand the mirror of her great-great-grandmother?

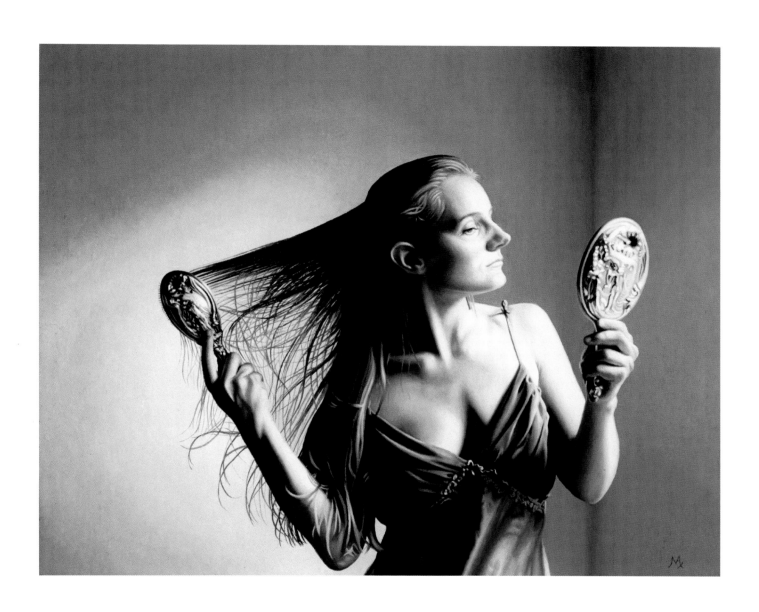

THE ROAD NOT TAKEN

oil on panel, 2016
12 × 12 inches / 30 × 30 cm

It was Lawrence's idea. This triple bill. He'd pushed for "The Lost Highway" over "Mulholland Drive", but was outvoted. Now, as it turns out he'll miss the show. En route to another journey altogether.

Atop the ladder, as he stretches to fix the "V" into its allotted place, Lawrence's mind is on higher things. Tomorrow will be his one-hundred-and-first skydive as a jump-master. Qualifying him, under the United States Parachute Association rules, to use a Go-Pro to video his clients. He's made sure that his first customer of the day will be Miriam. The parachute will open to put the brake on the unbelievable exhilaration of the free-fall. At that very moment he will whisper into Miriam's ear the words he now rehearses in his mind, And, as she says 'yes', which he's sure she will, he'll take the ring from his pocket and slip it onto the third finger of her left hand. The diamond will glitter in the rays of the rising sun. All filmed for posterity. A witness to all. A gentle descent back to earth and a marvellous future ahead.

'I love this cinema job,' he said two nights ago as he and Miriam were eating pizza after a Hitchcock double-bill ("The Birds" and "Vertigo"). 'But it's always been a means to an end. To get my licence. And to think of it … now I'll get to make my own films … up there. Where it's so quiet. So still. Four minutes between heaven and earth. Floating. Suspended. Film making and skydiving. My perfect combination!'

For Lawrence has been a risk-taker, a risk-seeker, all his life. Deep-sea diving. Freestyle climbing. Even a stint as a bounty hunter. He's relished every challenge. The riskier, the more extreme, the better.

He made her smile. His optimism. His sense of adventure and fun. But Miriam was terrified at the prospect. The idea of jumping into clear air. Fourteen thousand feet up in the sky. With him. In tandem. Just so she could be the first person he films?

'But it's crazy dangerous,' she'd said when he first suggested the idea.

'Couldn't be safer,' he replied.

He always had the statistics at his fingertips.

'In the last year only one person died world-wide from sky-diving. Do you know how many people died cycling bikes? Or pedestrians crossing roads?'

Eventually, she agreed. She'd meet him at six in the morning at the tiny airport by the river.

Tonight, sitting on her balcony she resolves not to back out. Even though he said she could. She decides to call him. To reassure him of her commitment. Maybe even say the words to him she's scared to say. In case … of what? Her own aversion to risk?

His phone rings. He reaches for his pocket. The ladder totters. He spreads his arms. Skyward. An attempt at balance. And, with the "V" still in his hand, Lawrence shudders in the awful realization that this shorter fall might prove to be the deadliest risk of all.

TIME

oil on panel, 2006
36 × 36 inches / 90 × 90 cm
Collection The Crystal Bridges Museum of American Art

On his way to work, Leon Lewandowski, eighty-one years old, once of Osiek, Poland, calls into Mr. Lubanski's shop to collect his tin of Dark Fired Kentucky tobacco. He passes the time of day with the friend he's known for five decades. They ask after each other's health. 'Remember. Only two minutes each,' says Mr. Lubanski, sharing the familiar joke, 'or else we'll bore each other to the grave.'

It's Kirsty Richards' last day with Caviar Couriers, the job she got to save up for her trip to Europe. The big adventure before taking up her scholarship at Penn State. She's just picked up a waffle order from Amy Ruth's on West 113th Street. She slings the rucksack on her back and jumps onto the fixed-wheel Pista she's borrowed from her room-mate. In two months' time, when Kirsty comes out of the coma (with a long lifetime of pain ahead of her) all she can remember is looking left on Malcolm X Boulevard. In his defence, the taxi driver, who was clocked at sixty-miles an hour, says his ride had told him to 'hit the gas' as his train was due in seven minutes.

Sitting by his work bench, Leon takes his curled pipe from the rack. It's his favorite, the one his father bought him to celebrate the day he handed the shop over to his eldest son. He rubs the tobacco between finger and thumb, relishing the feel of the leaves (slightly moist, verdant) and the smell (pungent, woodsy). He presses the tobacco into the bowl with the thumb of his right hand.

On the top floor of the Hospice of New York on Long Island City, Mr. O'Shea sits at his wife's bedside. He holds her hand, her fingers as stiff as pencils, her skin as dry and stretched as papyrus. She is still and distant, slowly drifting, gently meandering on her journey to mystery. Mr. O'Shea looks at his watch. At eight o'clock the nurse will bring breakfast on a tray. 'Beatrice,' he will say to his beloved wife, 'a nice cup of tea for you,' just as he has said on every morning of their forty years of marriage.

Leon strikes the match, never tiring of watching the flame ignite, the wood sizzle.

There are three seconds on the clock. Brooklyn Bridge Academy versus South Shore High School in the last game of the regular season, League A-East. Marvin Junior takes the pass inside the key. Two seconds. 'Shoot,' screams the coach. One second. Marvin flips the ball towards the hoop. His finger-tips releasing contact as the siren sounds. Everyone freezes as the ball arcs through the air. Marvin feels a single breath forcing itself from the depths of his lungs, up through his airwaves and out of his gaping mouth.

Relishing the moment, his day's work before him, Leon, perched on his chair, draws deeply on his pipe. He watches as the smoke, bluish, greyish, misty, circles the space overhead, twines and twists, then disappears.

THE NIGHT WATCH

oil on canvas, 2008
34 × 30 inches / 86 × 76 cm

The redwood of this desk. Cold and live to the touch. The bright white light. When all have settled in. Tucked up and cozy. Me the one awake. The one on duty. The night-time streetscape glimpsed and heard through squares of frosted glass. Occasional figures passing by, fragmented, recreated. Blues and darks and jig-sawed torsos. Sometimes almost familiar. Like clockwork. Like habit. Some shapes stop. To talk. To pat a dog. To tie a shoelace. To greet a friend surprised in the meeting. Then as the hours creep on. A slowing down. Occasionally a loner, to stagger and stumble. In this business of meeting life. And later, in the white dark of night, all can be quiet. All can be still. I will sit at my station. Watchful. In case of need, though need is rarely called upon. Long hours. Stretching.

Please, do not be mistaken. I am grateful. That is for certain. This job. It lets me think. Gives me time. Not just to reflect. Not just to remember how this life used to be. This singular life of mine that spread over continents. That witnessed world changing events. Then. Before now. Remembering. Remembrance. Memory … memories can be a curse; forgetting might be better. The greater healer. Not time. Forgetting. There was a Russian man I knew, I think he came from Sverdlovsk. He was trying to weigh time. You know how heavy it sometimes can be. And how light at others. Like children waiting for Christmas. And then the way the summer holiday flies away in an instant. Christmases. Summer holidays. Thoughts, fragments, like the man from Sverdlovsk, come and then they go. We had many long conversations, that man from Sverdlovsk and I. A lifetime ago. Drinking vodka. Eating pickled herrings. I see his face. His voice. But his name? Dmitri? Valery? By morning it will come to me.

But most of all, when the early hours buzz, the luxury to think. To explore the mind. Deep. To think and to converse. With myself. Or with the great poets, philosophers, painters. Those I invite to visit. Some who arrive announced, unexpected. They come to sit, to settle, in the lush red velvet chair. And we commune. Brecht. Paula Rego, St. Augustine, Rasputin, Ho Chi Minh. Whosoever finds their way … aha … Alexis … that was his name, the man from Sverdlovsk. His name way before the morning, before the dawn breaks. Alexis Valgurov. Brings a smile to my face to think of him. Now that he has a name to bring him back to life … and yet some nights it's just me. And just me is more than enough. Enough to ponder the unfathomableness, the bizarreness of it all.

Then like the time and the emptying of the chair, the morning insinuates itself upon the night. And I will stand up, leave my station, and always … always … run my hand along the red velvety upholstery of the armchair, having watched the night once more, having guarded well its secrets.

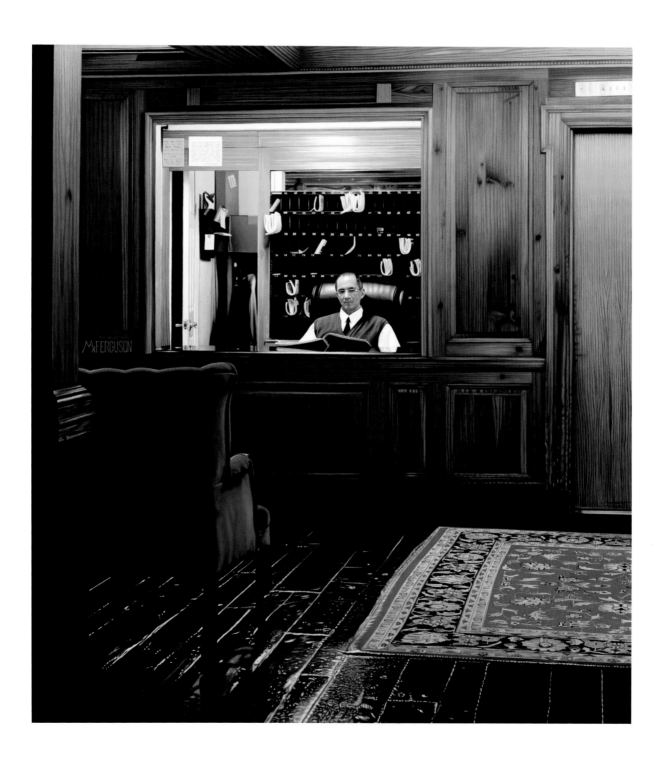

COAT CHECK GIRL

oil on panel, 2016
16 × 12 inches / 41 × 30 cm

Do you know that I'm looking at you? As you look into the distance. The girl with far away eyes. Can you tell, from the space between us? From that which flows? Do you sense that I'm wondering about you? I'm wondering if you're wondering is this a man I could fall for? Fall head over heels for?

You look above and beyond. Gazing into space. Do you think we could love? If I told you of my heart and what I make of this world?

When we talk (we will), you (the girl with far away eyes) and I (who's falling in love with our future), I will tell you about the man I'm thinking about as I think of you. Of his eighteen years as a forest monk in Lampang. Living off the alms of the poor. In silent meditation. In solitude. And I'll tell you why I think the universe brought us together. Yes, you and me, for sure. But also me and the forest monk. Some will say we meet by chance. All of us. Others see it otherwise. Streams of water in quest of a single path. A shared channel. The monk and I, together on a bench in the milky sun seeking and finding complicity. Me with my quantum entanglement (will you run from me at the words? the implication?). Of dualistic nature collapsing upon itself, choosing a single outcome. Like fate. Like destiny. Like you and I at this single instance in time. And he,

the forest monk, sublime, smiling, speaking of grasping and attachment. Of identities. Here and now. From moment to moment. As I wonder now what all this means to you and me? Now. If I resist the draw to seize this moment.

And yet, in this instance (for an instance is all it is, is all it takes) you beguile me. Your demeanour. All the atoms connected in the universe.

Soften the mind. Into action. I'll go into the street. But please don't disappear. Don't fall in love with another. Stay gazing as I rush into the cold and icy New York night. And I will empty my wallet. Three hundred dollar bills. And I will beg the men that pass me by to sell me a coat. Any coat. Here. Three hundred dollars. And one will say yes (for it's in all our natures), hurriedly checking the notes. As cheap and threadbare as the coat might be. And I'll come back to the space in which you gaze. And offer up to you my coat. A gesture. I will hear the sound of your voice. Like an angel it will be. Like breaking a fast. And I will tell you what I know. Not of science. Not of the presence of absence. But of longing. Of love. Of distances coming together. Of love and of the life you and I will forge together. This man with the threadbare coat, and you, the girl with the far away eyes.

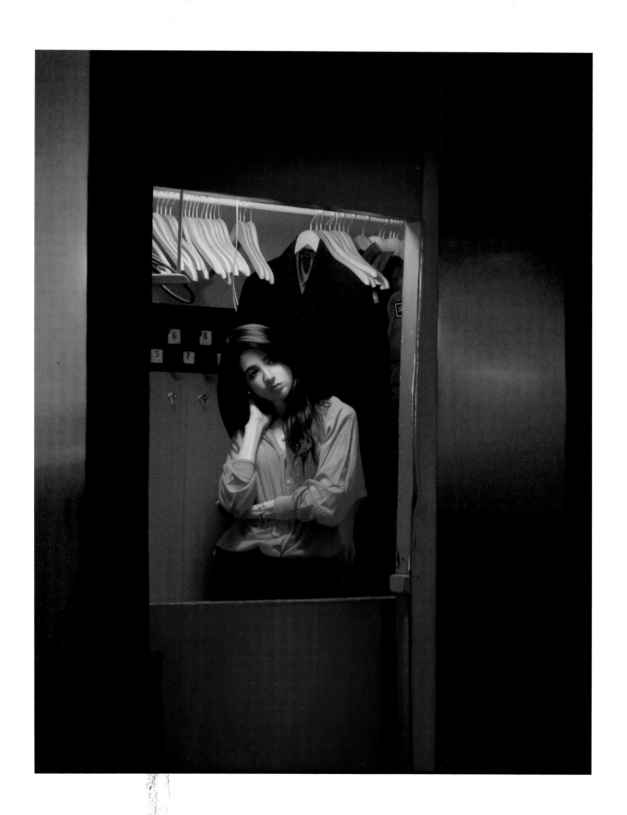

GIRL WITH VERMEER

oil on panel, 2014
18 × 12 inches / 45 × 30 cm

Since she was a little girl, for as long as she can remember, Miranda believed that what Alice said was so very true. That, like Alice, her reality was just different from yours. Different from her mother's, who told her to be more like her sister. Different from her sister's, who chastened Miranda to grow up and act more like an adult. And different from her teachers', who reported, year in, year out, that she should pay more attention to her lessons and less to her daydreams. But it was her daydreams she relished. Dreams of being elsewhere; somebody other. Not that she'd ever say as much. She'd just smile at her mother. Ignore her sister. Lower her eyes at teacher-parent interviews. In the town where she lived. "A town like Alice", she used to say (mimicking the black and white movie she loved, that seemed so unlike the world her family thought they lived in). As a young child, sitting outside church, she'd look into people's faces as they walked by. Trying to fathom what they made of it all. The little events. The comings and goings of life. Everyone's own distinct view of the world. She would imagine being each one. The babe in arms. The old man with the walking stick. The stray dog. The priest in his finery. The street cleaner. The unique world that lived inside every head.

But the strangest thing of all to Miranda was that it was never Alice (even when she was in Wonderland) who said her reality was different from yours. Rather, someone imagining Alice thinking that way. So when she became an adult woman (not Alice, who never would, but Miranda, who did) and ran away to live in New York, she'd spend hours in art museums. Looking at one painting at a time. She had her favorites. Pictures that she'd return to. Spend time with. Best of all on a weekday. First thing in the morning. Before the crowds. Just gazing. Envisioning other worlds. Different ways of seeing. Every time, as on this November morning, that Miranda studied Vermeer's young girl holding the water jug she'd stare and stare until, like Alice and the looking glass, she'd step into the painting. She'd smile the young girl's smile and see what she saw in the world outside. Hear the neighing of the horses, the clanking of the bridle and harness, the clatter of the wheels. Watch the coach as it passed by. Disappearing at the corner. Then she would turn from the window, careful not to spill any water from the pitcher. She'd look up at the map on the wall and imagine herself, far away, in another town. In another life. Just as Miranda did, as her young girl self, searching for the rabbit hole. Like the time she found a map of Australia, put her finger on a town like Alice, deep in the deserty red centre, closed her eyes, clicked her heels and waited. Waited.

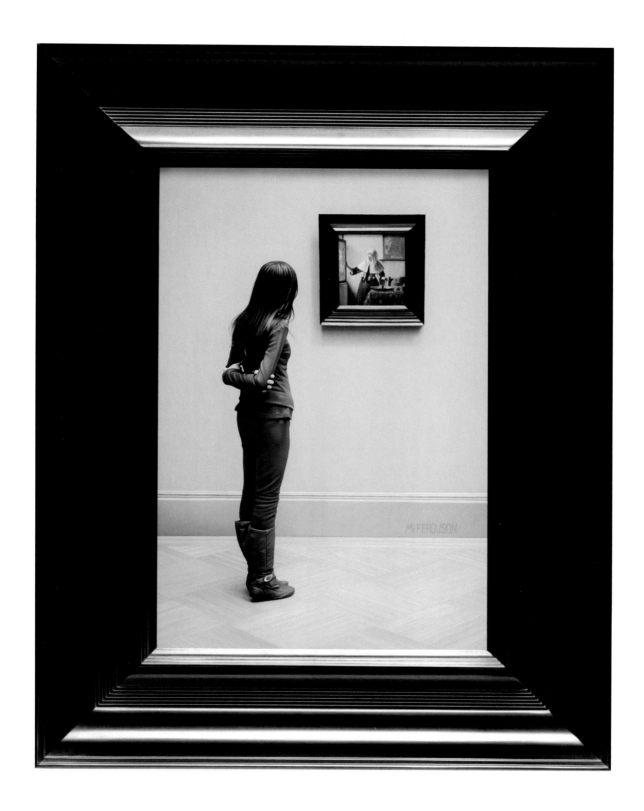

REPRODUCTIONS

LULU IN NEW YORK
oil on panel, 2014
12 × 12 inches / 30 × 30 cm

DOLL HOSPITAL
oil on panel, 2005
30 × 20 inches / 76 × 50 cm

POPCORN
oil on panel, 2015
30 × 44 inches / 76 × 112 cm

**CLOSING TIME/
VILLAGE VANGUARD**
oil on canvas, 2016
20 × 30 inches / 50 × 76 cm

STRAND BOOK STORE
oil on panel, 2010
16 × 22 inches / 40 × 55 cm

WOMAN IN MIRROR
oil on panel, 1994
12 × 12 inches / 30 × 30 cm

SUBTERRANEANS
graphite and chalk on paper, 1991
20 × 30 inches / 50 × 76 cm

MR. SOFTEE
oil on panel, 1985
27 × 45 inches / 68 × 112 cm

COUPLE IN HALLWAY
oil on panel, 2009
12 × 9 inches / 30 × 22 cm

DIGNITY
oil on board, 1999
11 × 14 inches / 28 × 36 cm

BROADWAY CHECKER
gouache on paper, 1986
26 × 26 inches / 66 × 66 cm

CHESS PLAYERS
oil on panel, 1991
30 × 19 inches / 75 × 48 cm

BOBBY SHORT
oil on panel, 1996
19 × 30 inches / 48 × 76 cm

RESERVOIR IN SPRING
oil on panel, 1997
7 × 48 inches / 18 × 121 cm

BLEECKER STREET
oil on panel, 1984
30 × 40 inches / 76 × 100 cm

SPRING STREET
oil on panel. 1985
16 × 24 inches / 42 × 61 cm

BAGEL BAKERY
oil on panel, 1996
29 × 29 inches / 73 × 73 cm

JUKE BOX
oil on panel, 2016
18 × 12 inches / 46 × 30 cm

**MAN ENTERING
SUBWAY STATION**
oil on panel, 1983
16 × 18 inches / 40 × 46 cm

CENTRAL PARK NOCTURNE
oil on canvas, 2004
44 × 29 inches / 113 × 74 cm

SHOE REPAIR SHOP
oil on panel, 2008
16 × 16 inches / 40 × 40 cm

ATLANTIC CITY
oil on canvas, 1998
30 × 40 inches / 76 × 100 cm

CONEY ISLAND SELF-PORTRAIT
oil on panel, 1989
20 × 30 inches / 50 × 76 cm

WOMAN IN CAFÉ
oil on panel, 2009
12 × 12 inches / 30 × 30 cm

LATE IN THE DAY
oil on canvas
20 × 30 inches / 50 × 76 cm

BILLY'S TOPLESS
oil on panel, 1991
20 × 30 inches / 50 × 76 cm

ANDREA IN FLORENCE
oil on panel, 1979
16 × 20 inches / 40 × 50 cm

TAXI DRIVER II
oil on panel, 2005
6 × 9 inches / 15 × 23 cm

EAST 72ND
oil on panel, 2015
11 × 14 inches / 28 × 36 cm

COFFEE
oil on panel, 2015
27 × 27 inches / 68 × 68 cm

MR. GORDON
oil on panel, 2002
16 × 20 inches / 40 × 50 cm

**HANDBALL PLAYERS
(CONEY ISLAND)**
oil on canvas, 2002
11 × 14 inches / 28 × 36 cm

MOTHER AND DAUGHTER
oil on canvas, 2013
30 × 42 inches / 76 × 106 cm

PAGEANT BOOKS
oil on panel, 2009
12 × 12 inches / 30 × 30 cm

MY FATHER IN KATZ'S
oil on panel, 2005
16 × 20 inches / 40 × 50 cm

**CHESS PLAYERS,
WASHINGTON SQUARE PARK**
graphite on paper, 1980
14 × 22 inches / 36 × 56 cm

CAVALIER HOTEL
oil on panel, 1984
20 × 16 inches / 50 × 40 cm

INTERIORS
oil on panel, 2009
30 × 42 inches / 76 × 106 cm

NEWS VENDOR
oil on panel, 1986
32 × 41 inches / 80 × 105 cm

BAR WITH POOL TABLE AND PIANO
watercolor on paper, 2008
9 × 12 inches / 22 × 30 cm

WOMAN WITH UMBRELLA
graphite on paper, 2003
9 × 11 inches / 22 × 28 cm

YANKEE STADIUM
oil on panel, 1992
15 × 23 inches / 38 × 59 cm

SELF-PORTRAIT AT JULIAN'S
oil on panel, 1994
30 × 20 inches / 76 × 50 cm

MY FATHER AT MOUNT SINAI
oil on canvas, 2011
36 × 52 inches / 91 × 142 cm

KATZ'S V
oil on panel, 2010
20 × 20 inches / 50 × 50 cm

WOMAN IN COFFEE SHOP
oil on panel, 1982
16 × 20 inches / 40 × 50 cm

COLONY HOTEL
oil on panel, 1999
29 × 29 inches / 74 × 74 cm

HIS FATHER'S GLASSES
oil on panel, 2016
12 × 18 inches / 30 × 45 cm

GIRL IN MIAMI
oil on panel, 1999
20 × 30 inches / 50 × 76 cm

HARLEM NOCTURNE
oil on panel, 1985
24 × 17 inches / 61 × 43 cm

MATINEE
watercolor on paper, 2015
12 × 18 inches / 30 × 46 cm

WOMAN IN BATH
oil on panel, 2009
11 × 8 inches / 28 × 20 cm

TEA
watercolor on paper, 2000
6 × 10 inches / 15 × 26 cm

MY FATHER IN THE SUBWAY III
oil on panel, 1984
22 × 28 inches / 57 × 72 cm

WOMAN BRUSHING HER HAIR III
oil on panel, 2001
8 × 10 inches / 20 × 25 cm

THE ROAD NOT TAKEN
oil on panel, 2016
12 × 12 inches / 30 × 30 cm

TIME
oil on panel, 2006
36 × 36 inches / 90 × 90 cm
Collection The Crystal Bridges
Museum of American Art

THE NIGHT WATCH
oil on canvas, 2008
34 × 30 inches / 86 × 76 cm

COAT CHECK GIRL
oil on panel, 2016
16 × 12 inches / 41 × 30 cm

GIRL WITH VERMEER
oil on panel, 2014
18 × 12 inches / 45 × 30 cm